An Arab Family

LIBRARY OF CONGRESS CATALOGING IN PUBLICATION DATA

Dutton, Roderic.
 An Arab family.

 Rev. ed. of: Arab village. 1980.
 Summary: Depicts life in a small village in Oman.
 1. Al Khāburah (Oman)—Juvenile literature.
2. Oman—Social life and customs—Juvenile literature.
[1. Oman—Social life and customs] I. Free, John
Brand, ill. II. Title.
DS248.A44D87 1985 953'.53 85-10272
ISBN 0-8225-1660-8 (lib. bdg.)

Manufactured in the United States of America

 3 4 5 6 7 8 9 10 95 94 93 92 91 90

An Arab Family

Roderic Dutton

Photographs by John B. Free

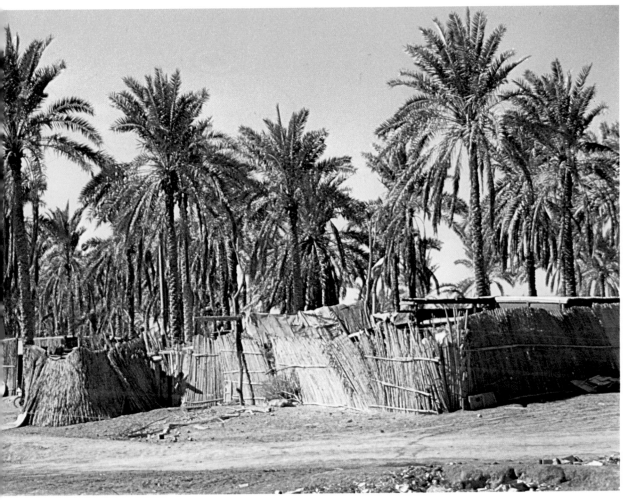

Lerner Publications Company · Minneapolis

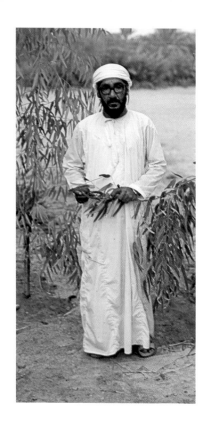

This is Mohammed. He lives with his family in the village of Khabura on the shores of the Indian Ocean. Khabura is in Oman, a country on the tip of the Arabian Peninsula.

Mohammed and his wife Zainab have six sons and three daughters. The youngest boy is still a baby, and the two oldest girls are already married. Hadiga, the only unmarried daughter, lives at home and helps take care of the house.

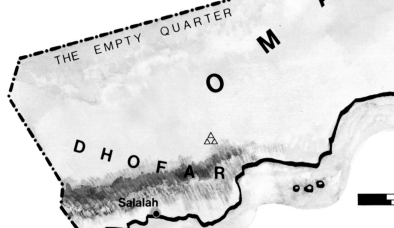

Sohar

Khabura

Jabal Akhdha

Nizwa

THE EMPTY QUARTER

O M A N

DHOFAR

Salalah

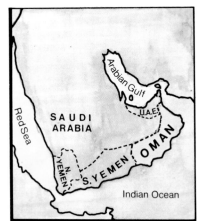

Red Sea

SAUDI ARABIA

Arabian Gulf

U.A.E.

N. YEMEN

S. YEMEN

OMAN

Indian Ocean

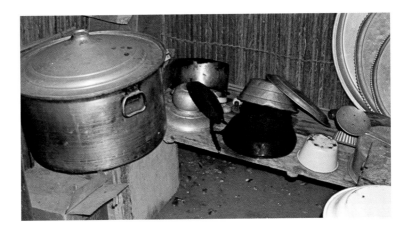

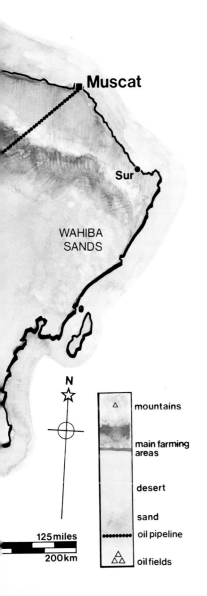

Muscat

Sur

WAHIBA
SANDS

N

mountains

main farming
areas

desert

sand

125 miles
200 km

oil pipeline

oil fields

Zainab does all the cooking over an open fire. She uses lots of pots and pans, which Hadiga later scrubs clean. They have no electric stoves or washing machines to make housework easier.

When Mohammed is out, Zainab sometimes invites her women friends over for coffee. They eat dates and discuss the local news.

Zainab owns a sewing machine, and she and Hadiga use it to make their clothes. The women in Oman wear beautiful, brightly colored dresses over loose-fitting trousers. The men wear long white robes, which they buy from the tailors in the village market.

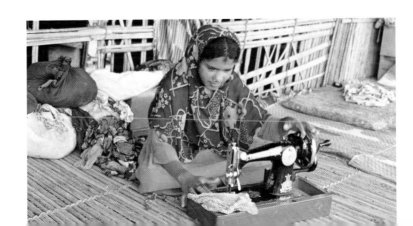

When Mohammed's first child was born, there weren't any schools in Khabura. But in 1970, Sultan Qaboos became Ruler of Oman, and he had many schools built. Now all the children in the village go to school. Mahmoud, Mohammed's oldest son, works hard and hopes to become a doctor or an airline pilot one day.

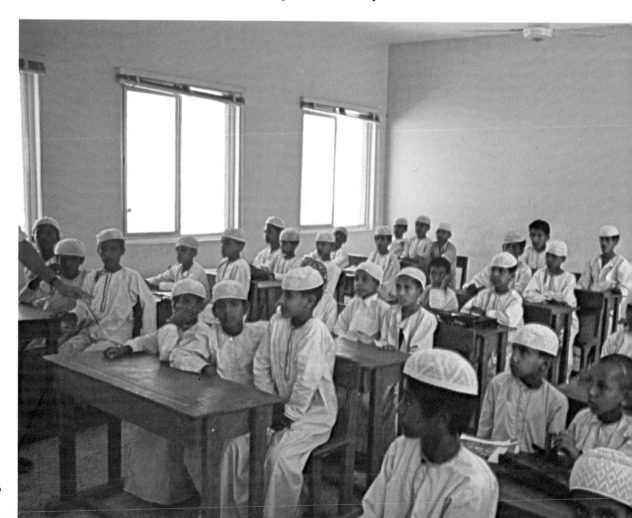

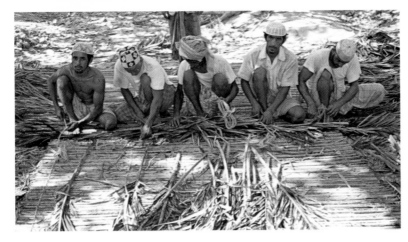

There are many new buildings in Khabura, all built using concrete blocks. Houses used to be made of date palm leaves, knotted together by hand. Now workshops in every village make concrete blocks.

Khabura also has a new electric power plant. Mohammed hopes to have electricity in his home soon. Then he can install electric lights in his house and maybe even buy some modern appliances.

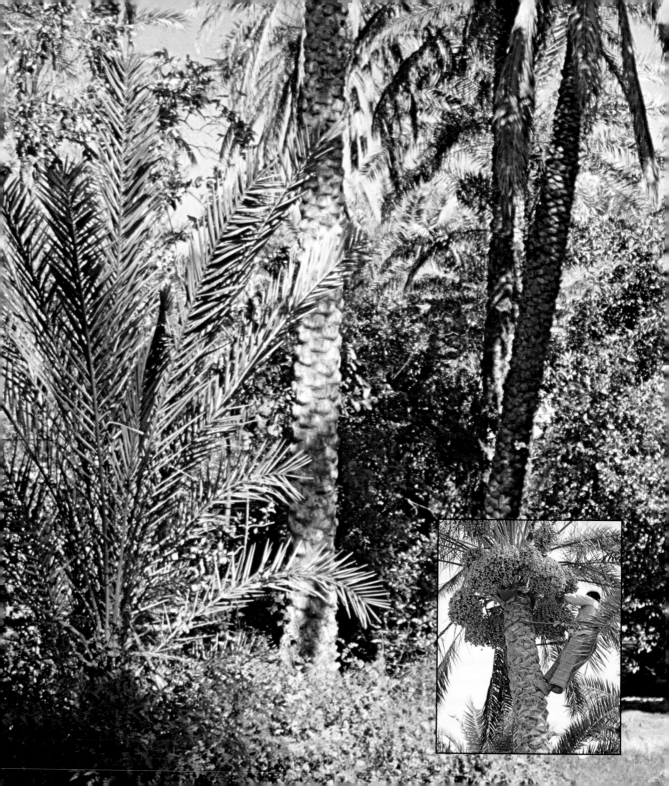

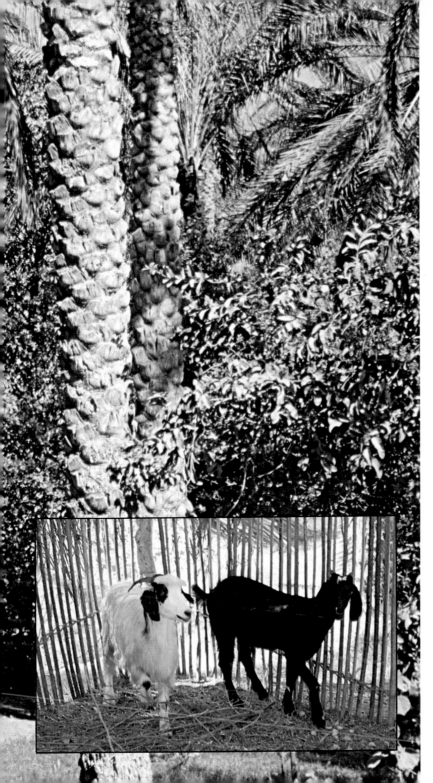

Mohammed's house stands in the middle of a tiny farm. Here Mohammed grows dates, limes, mangoes, and bananas.

The dates ripen during the hot summer months and are picked by men who climb the date palm trees. Some of the dates are eaten fresh. The rest are dried in the sun and saved for winter.

Most of the limes are dried and sold to a man in the village market. Mohammed keeps some fresh limes because his family likes to squeeze the juice over rice and meat.

There are also two goats in Mohammed's yard. Many people in the village keep a few animals. They might have a cow that they milk or a goat that they plan to eat at a festival.

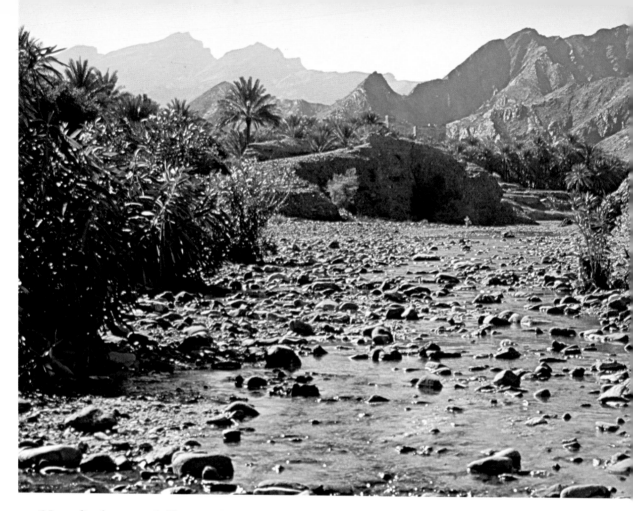

Very little rain falls on the gardens of Khabura. Usually, it rains only three or four days out of the whole year. Some years there is no rain at all.

But rain does fall on the mountains, which are inland. That water seeps into the earth and flows underground toward the coast. The villagers dig wells to get enough water to drink, wash, and water their crops.

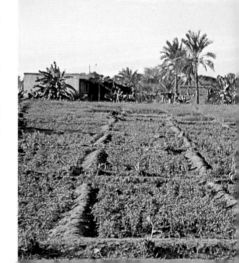

Water for the crops is pumped out of the wells by engines. In Mohammed's yard, water flows into a concrete basin. The children often use it as a pool to play in.

Then the water flows through a network of small ditches to water the crops. Without these ditches, the gardens would be as dry as the plains around Khabura.

One crop which needs a regular supply of water is alfalfa. It is grown as food for the animals. Farmers can also earn money by selling alfalfa for high prices to neighboring Arab countries.

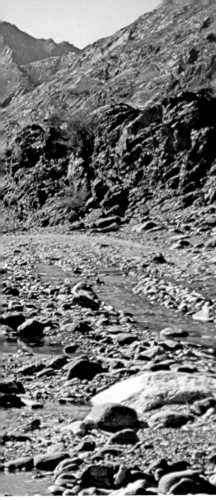

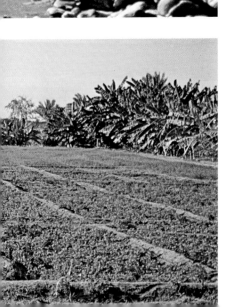

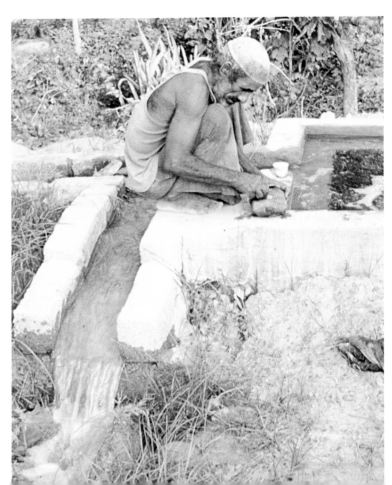

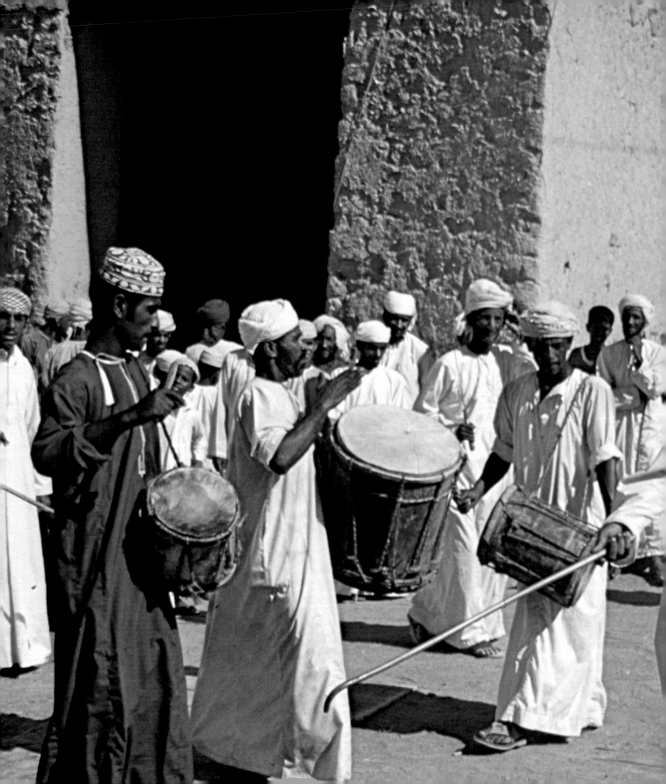

Everyone who lives in Khabura is Muslim. The high point of their year is Ramadan, the holy month of fasting. During this month Muslims don't eat or drink anything during the hours of daylight.

At the end of Ramadan, there is a big celebration. The people of Khabura dance in the square by the old fort.

Mohammed makes a special meal for his family and friends. Just before the end of Ramadan he buys a goat at the market. He kills the goat and then prepares it for cooking while his friend carefully rubs salt into the goatskin to preserve it. Later on, the skin will be made into a leather bag. It will be used as a churn, to separate butter from cows' milk.

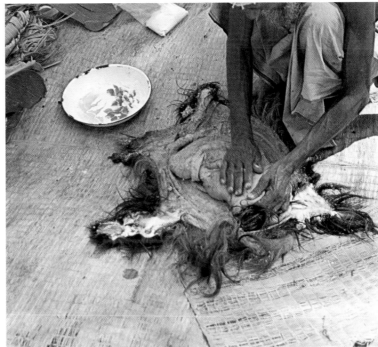

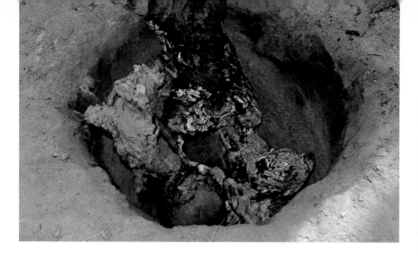

Most of the meat is cooked in a *tanour*. A *tanour* is a hole in the ground that is used as an oven. Mohammed lights a fire in the *tanour* and lets it become very hot. He wraps the meat in leaves, waits until the fire turns to ashes, and then throws the packages of meat into the *tanour*.

The hole is then covered with earth to keep the heat in and left for 24 hours. When Mohammed takes the meat out of the *tanour*, it is ready to eat.

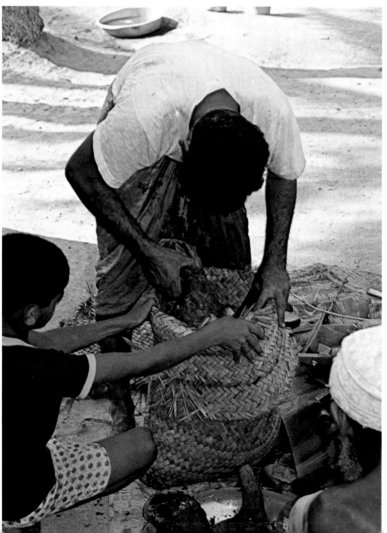

Families in Khabura usually eat together. But on a special occasion like this one, the women eat separately from the men.

The men sit on the ground, around a big central dish heaped with meat, rice, and dates. Afterwards, they eat fruit and *halwa* and drink strong black coffee.

Halwa, also called halvah, is a flaky, sweet dessert usually made of crushed sesame seeds and honey.

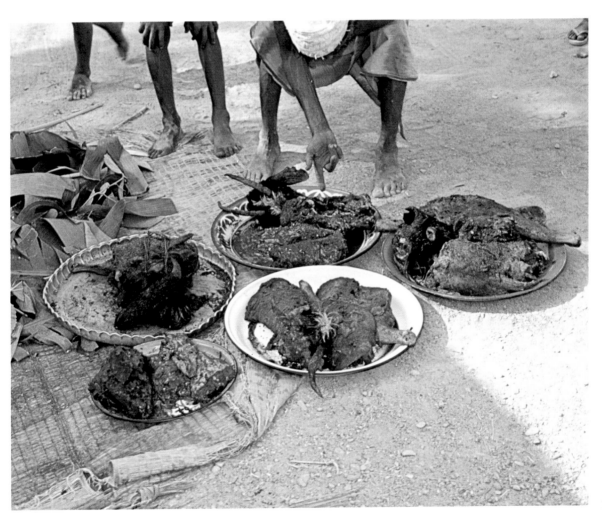

Mohammed's oldest daughter, Fatima, and her husband, Rashid, live in the nearby village of Khuwayrat. In Khuwayrat, most men are part-time fishermen. If they catch a lot of fish, they take them to the market in Khabura to be sold.

Rashid comes from a fishing family. He and his brother own two small boats. They are made from date palm leaves and have been built in the same way for hundreds of years.

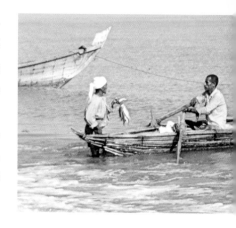

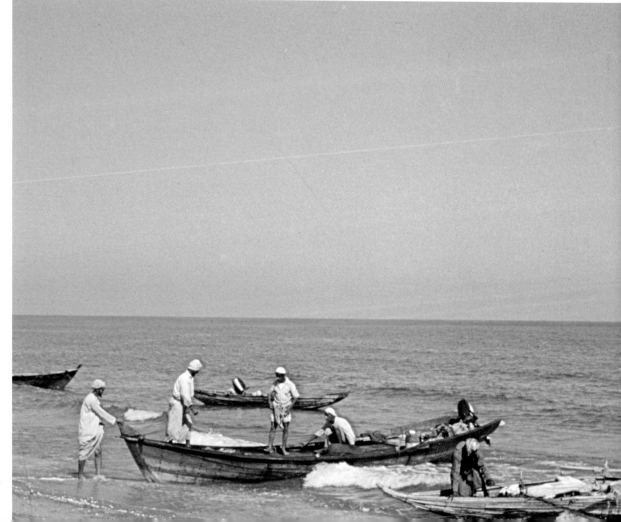

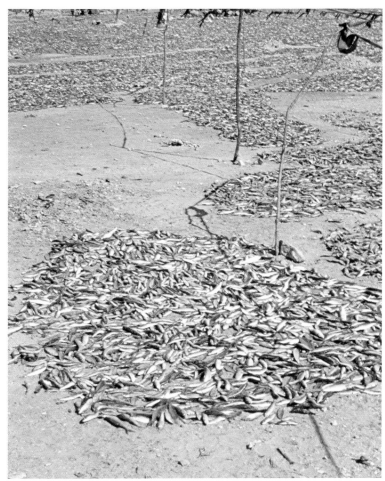

Rashid doesn't always have time to fish, because he also owns a store and a workshop that makes concrete blocks. But when the brothers think there are plenty of fish, they take their boats to sea. Then they spread the nets and set their traps.

Sometimes shoals of sardines swim near the shore. Fishermen in boats lower nets around the fish. Then everyone in the village wades into the sea to pull the nets ashore. The sardines are spread out on the beach to dry in the sun.

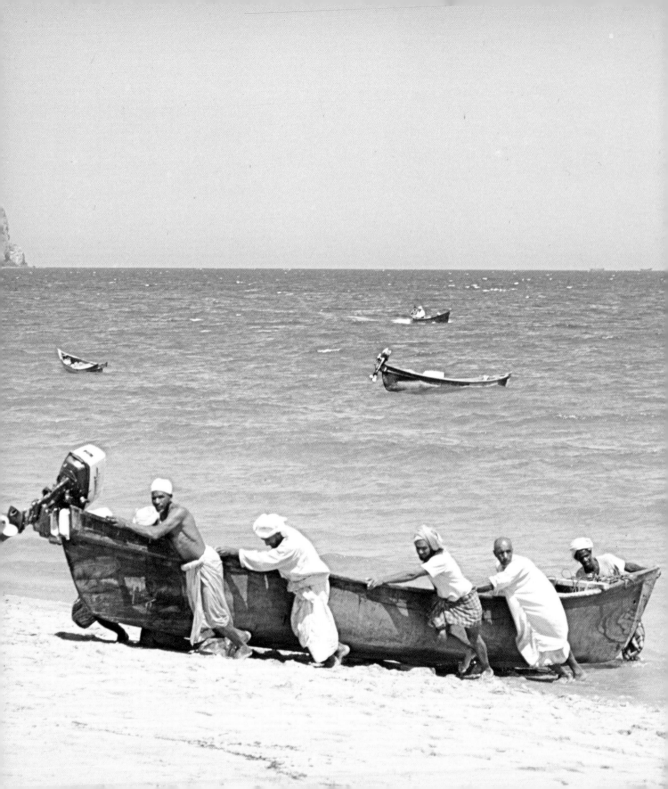

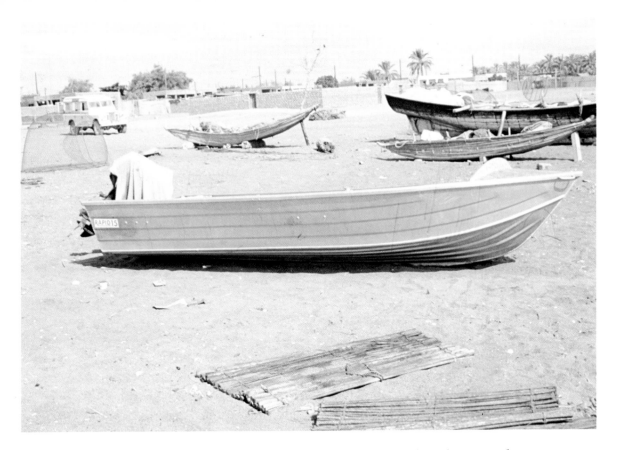

Many of the palm leaf fishing boats used to have sails. Others were rowed with oars. Now many of the boats have engines and rarely will a fisherman row.

Some fishermen use larger wooden boats. These boats can carry more nets and bring back more fish. They can stay longer out at sea, but are heavy to pull up on to the beach. All the wooden boats have big engines.

Recently, fisherman have been buying light metal boats from the government. They like these boats because they are cheap and easy to carry ashore.

The fishermen in Khuwayrat catch most of their fish at night or very early in the morning. In the afternoon, they repair their nets, sometimes with the help of the whole family. The beach is covered with floats, nets, anchors, and wire fish traps.

These traps are made in the village. One day two of Mohammed's cousins came to Khabura and asked if he would find some fishing traps for them. They knew that the craftsmen in the fishing villages near Khabura make good traps at reasonable prices.

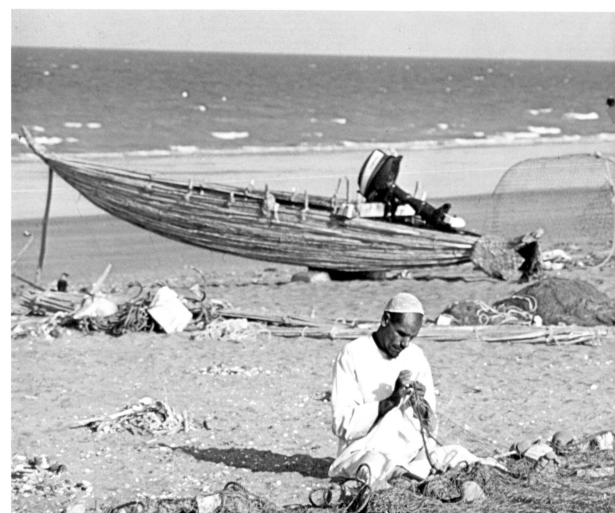

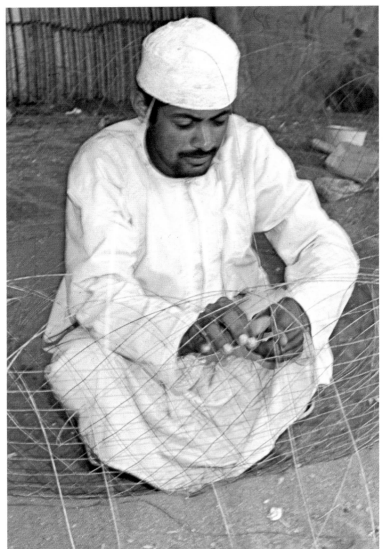

One of the trap-makers agreed to make the traps but explained that the price would be higher than Mohammed had paid because the cost of the wire had risen sharply. Mohammed still thought the trap-maker was asking too much. The two men discussed the situation until they finally agreed on a price.

21

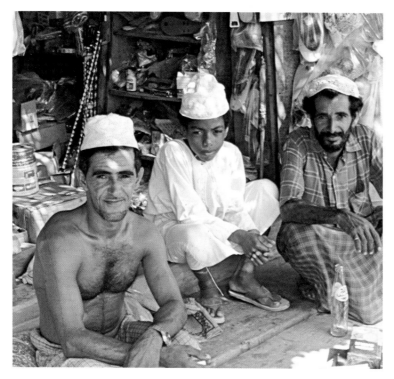

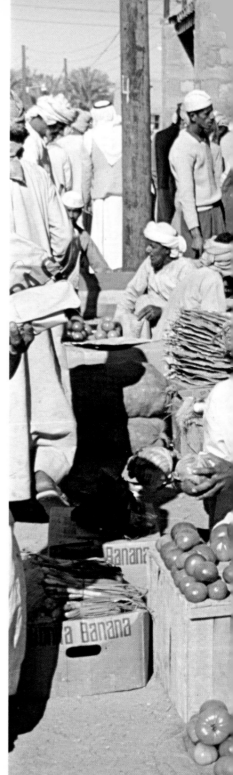

Mohammed does most of the family food shopping. Each week he goes to the market in the center of Khabura to buy rice, flour, coffee, fruit, and *halwa*.

He buys fish from the market every day. He either buys a piece of fish from a fish trader or a whole fish from one of the boats as it arrives in the market.

The market has grown very rapidly in recent years. New shops have been built and there is now a wide choice of goods. Villagers can buy radios, canned food, and even children's bicycles.

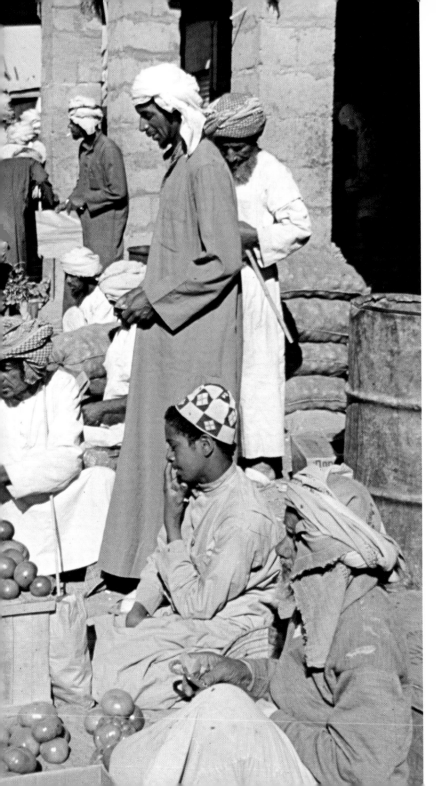

Mohammed used to own more land than he does now, and he employed people to work on it. Now the young men who worked for him have joined the army, where they can earn more money.

Mohammed is still an important man in the village. His opinions are trusted, and he is often asked to settle arguments between neighbors.

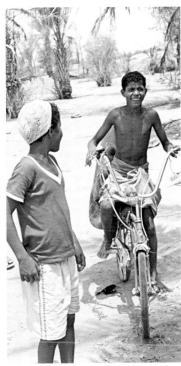

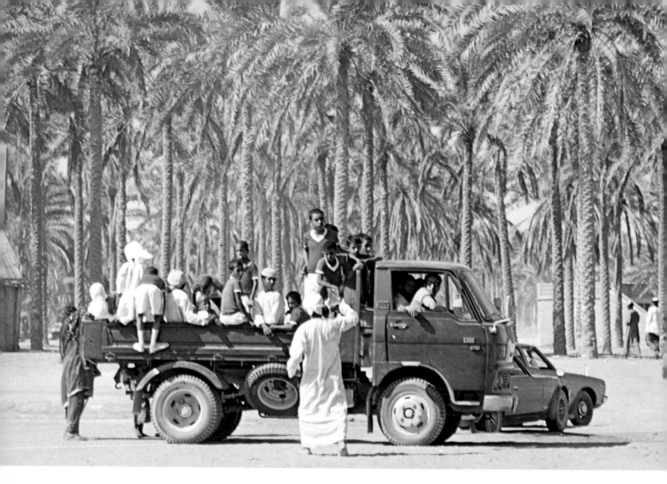

Recently, Mohammed bought a small truck. He drives this to big towns like Muscat or Dubai, which is in the neighboring country of the United Arab Emirates. He buys building materials or fruit and rice and brings them back to Khabura. Then he resells them in the market at a higher price.

A few years ago, Mohammed would have bought a camel, not a truck. "Camel trains" were once a common sight, but now trucks transport most goods.

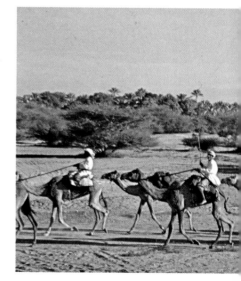

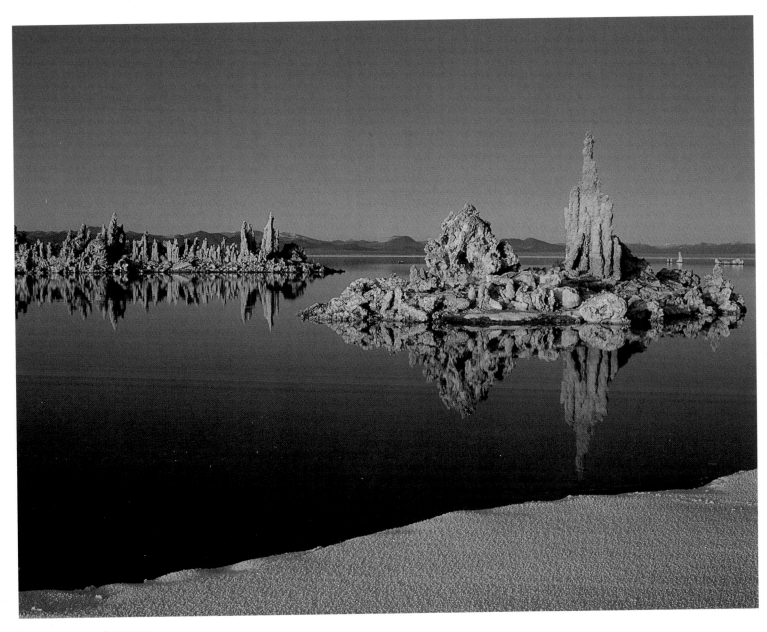

TUFA TOWERS, JANUARY

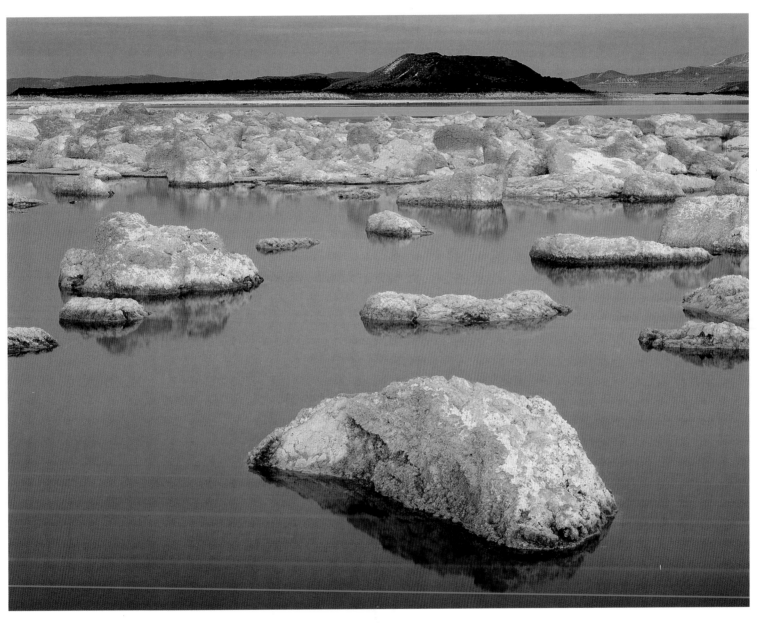

NEGIT ISLAND, OCTOBER

3

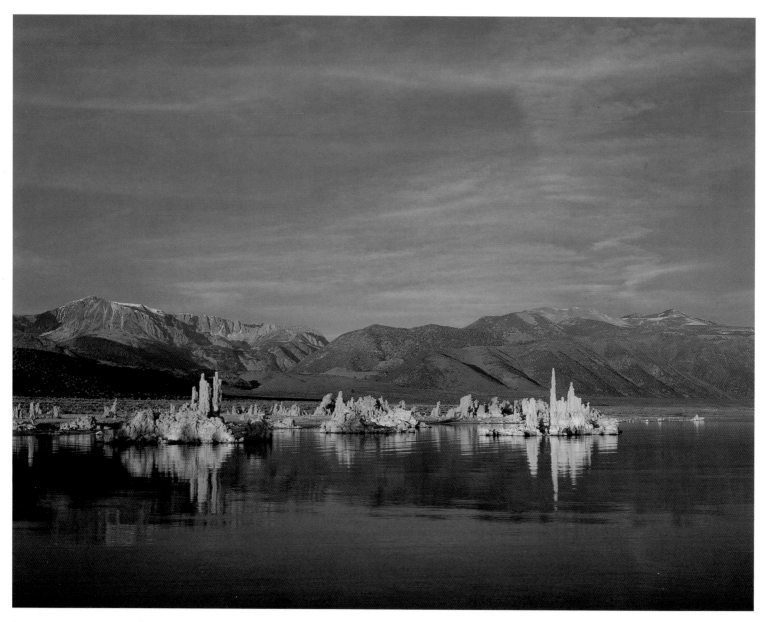

MONO LAKE AND THE SIERRA NEVADA, APRIL
Early morning light bathes the tufa towers at Mono Lake's south shore. The foothills and snow-dusted peaks of the Sierra Nevada Range rise to the west.

MONO LAKE

Mirror of Imagination

Photography by
Dennis Flaherty

Essay by
Mark A. Schlenz

COMPANION PRESS

SANTA BARBARA, CALIFORNIA

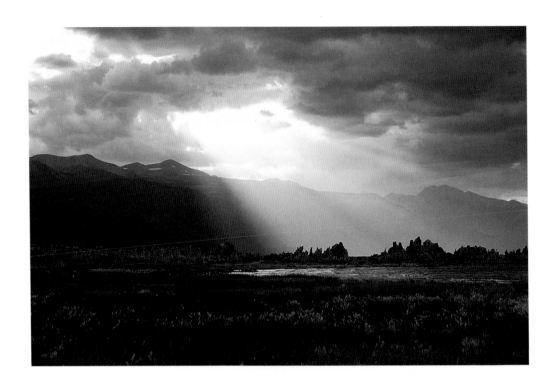

Companion Press
464 Terrace Road
Santa Barbara, CA 93109
Jane Freeburg, Publisher/Editor
Designed by Lucy Brown

Printed and bound in Korea
through Bolton Associates
San Rafael, California

ISBN 0-944197-44-2 (paperback)
ISBN 0-944197-45-0 (clothbound)

96 97 98 99 01 🍂 5 4 3 2 1

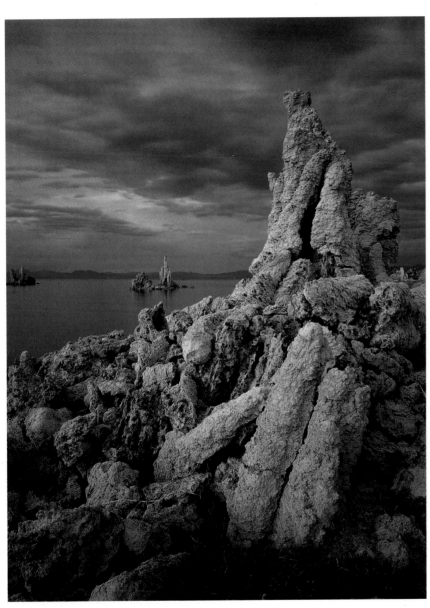

TUFA FORMS AT TWILIGHT, OCTOBER

Receding lake levels exposed these distinctive tufa towers, which were formed when freshwater springs welled up through Mono Lake's alkaline waters.

CONTENTS

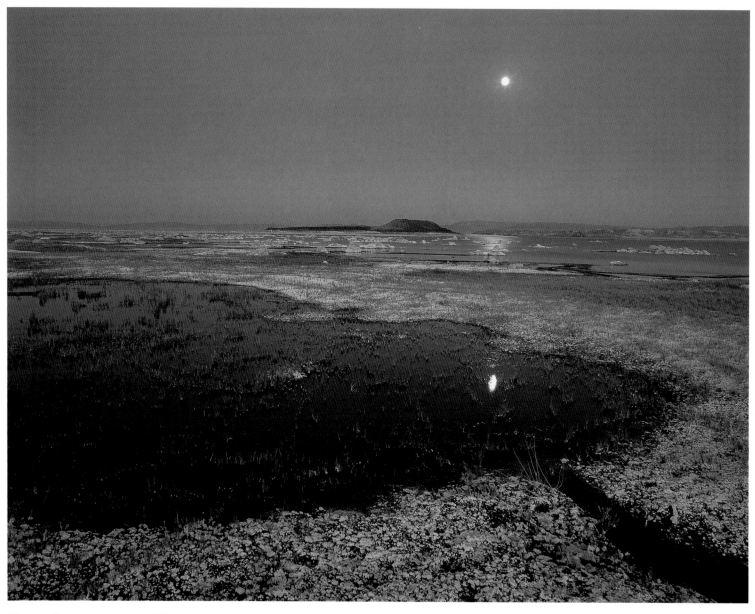

NORTH SHORE MOONRISE, NOVEMBER

OPPOSITE: SUNSET SKY OVER MONO LAKE, JULY

PREFACE

When I photograph Mono Lake, I am most often alone. After I set up my camera, I let my imagination take hold. I am flooded with the sublime beauty of this inland sea, with its awesome diversity, nurturing solitude, and miles of shoreline vistas. I listen to the sounds of the birds and let the salt-scented air fill me with the presence of the seashore, here where the gently waves breaking echo the memories of all oceans in the continuum of geologic time. As the colors of the sky grow richer and deeper, I await the magical moment when nature will display its most vivid secrets. Celebrating these special times at the lake by sharing my photography with others helps me communicate my passion for Mono Lake's subtle beauties. Mono Lake is rare, precious and wild—yet we have come perilously close to losing this most ancient of American lakes. May the collection of words and images gathered here help restore and foster stewardship of Mono Lake's un-equalled landscape and ecosystems.

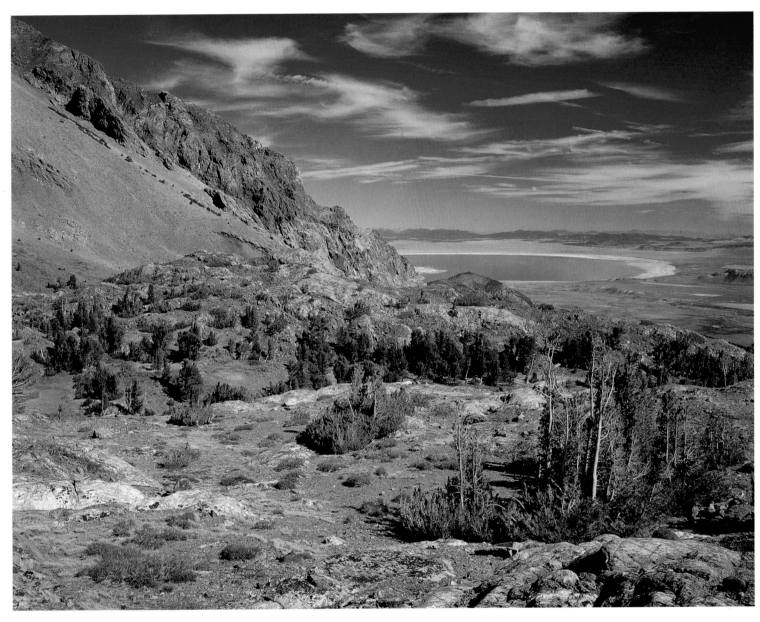

VIEW FROM THE TOP OF BLOODY CANYON, OCTOBER

A vista from a resting point on the centuries-old trail leading down from Yosemite displays Mono Lake and the Mono Basin spread far below.

10

*From the commanding summit of Mt. Dana nearly
the entire Mono Basin is in view, and we may
study, as from a map, the principal features of
our field of exploration.*

–ISRAEL C. RUSSELL
*Quaternary History of the Mono Valley,
California* from the *Eighth Annual Report
of the United States Geological Survey, 1889*

MONO LAKE:
MIRROR OF IMAGINATION

Viewed from atop Mount Dana, over 13,000 feet high on the Pacific Crest of the Sierra Nevada, Mono Lake lies before the advancing dawn like a celestial font eternally awaiting the imaginary ablutions of my morning meditations. As first-light broaches the eastern horizons from beyond the silhouettes of the Cowtrack Mountains, the Glass Mountains, and the White Mountains, the pastels of sunrise pool into the lake, gently illuminating its waters in the still-darkened embrace of the basin. Its islands—Negit and Paoha and their scattered islets—are etched in blackness like fragments of lingering night upon the lake's shining daybreak surface. Keeping eternal watch, like a huge unblinking eye, Mono Lake stares solemnly into the skies as it has for aeons—watching and reflecting the shining paths of stars and the endless alternation of days, meditating impassively upon the migrations of sun and moon, the mysterious comings and goings of clouds, the shimmering shapes of mountains, and the infinite flight patterns of flocking birds. As day grows, I witness the return of shape and definition to the landscape. The Bodie Hills, the Mono Craters, the serried ridges of the Sierra retake their familiar forms from night's retreat until, as the sun itself rises from behind Cowtrack Mountain, the entire rim of all the basin—and seemingly all it holds— lies within the scope of my gaze.

And still my eyes, and mind, and contemplations return to the glowing waters of Mono Lake as they reflect the brightening desert skies: and I try to fix forever in my imagination and memory

the particular shape of the lake's entire shoreline as it lies illuminated this particular late-summer morning. After another season of visiting its shores and paddling its waters, I had climbed up here the night before to consider more fully the significance of the year's extraordinary events in the life of Mono Lake: What would be the ultimate outcome of last fall's court orders restoring stream flows to the lake? How will run-off from the winter's record snowfalls affect the lake's salinity? How will rising lake levels affect the basin's habitats? What will our society learn about water resources management in the American West from the struggle to save Mono Lake?

Last night I recalled Israel Russell's overview of Mono Lake and its basin from this same summit in his 1889 quaternary history of the region. In the lengthening shadows of the long evening, I too imagined the landscape displayed in my view as a map. The landscape I saw was sharply etched with isometry lines in concentric circles extending from the present shore-line of Mono Lake like a huge three-dimensional topographic map giving graphic relief to geologic, prehistoric, and historic recessions of the lake's waters. More than a map of space, the view of Mono Basin from atop Mount Dana seemed to me in the waning day to suggest a map of time—of history, and, perhaps, of possible futures. Like the growth rings of a fallen log, the shaded outlines of Mono's ancient beaches and newly exposed playas told a story of a life, of struggle and survival. They preserve a record of geologic—and human—earth-shaping forces; they tell of the ways of volcanic fire, and of the ways of glacial ice, and even of the ways of hydrologic engineering, but most of all they tell a tale of the ways of water.

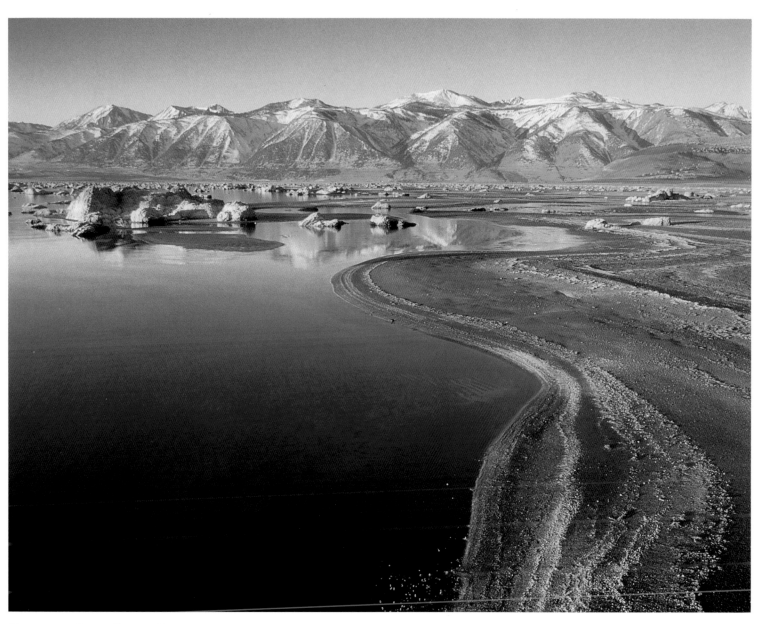

VIEW FROM BLACK POINT, DECEMBER

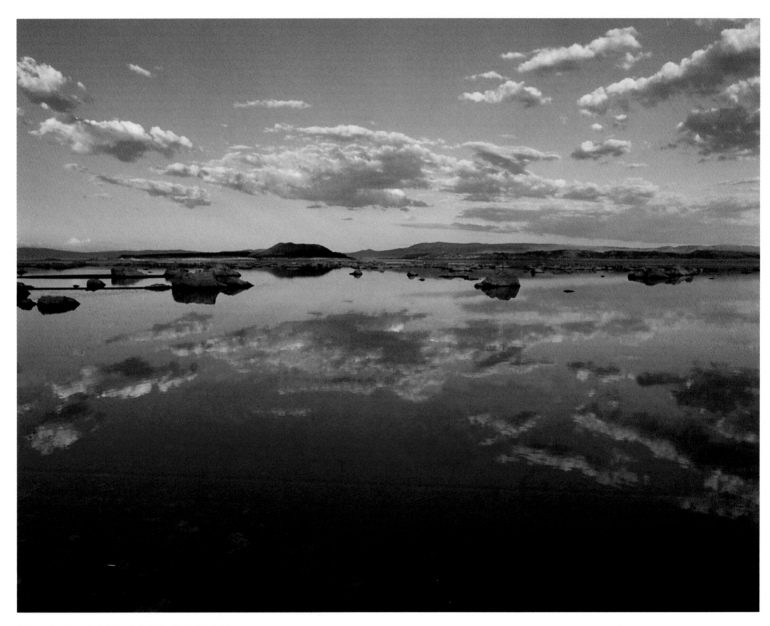

CLOUDS OVER MONO LAKE, SEPTEMBER

The highest good is like water.
Water gives life to ten thousand things
and does not strive. It flows in places
men reject and so is like the Tao.

–LAO TZU

WAYS OF WATER

Water provides conditions necessary for life on our planet. For human life, however, this involves more than satisfying only physical requirements of existence. Water nourishes our imagination, perhaps our most essential human survival need. The reflective capacities of water inspire reflective capacities of the human spirit. The photographic images of the waters of Mono Lake gathered here might be understood as one artist's contribution to our understanding of the imaginative ways of water—the ways in which, for instance, a saline, desert lake in a place "rejected by men" can flood the human soul. They might also be understood as testimony to the critical ecological significance of our uses and abuses of vital water resources in the American West. Just as the sinuous shorelines, illuminated tufa formations, and evocative island reflections captured in these images speak to our personal contemplative nature, they also document historic lake level fluctuations that speak to our social environmental responsibilities.

Understanding the ways of water as it flows through our environments, our bodies, and our imaginations may enable us finally to better understand ourselves. Certainly, better understanding of how we organize the use of water in our communities—how we divert, channel, legislate, and litigate its course—will yield fuller understanding of a critical and determining environmental element of our social, economic, political and cultural histories. The waters of Mono Lake have long challenged the imaginations of human occupants and visitors to the region—how to comprehend their strange sublimity; how to make some practical use of their vast volume in an arid land? Our capacity to imagine creative and appropriate answers to these challenging questions—answers that will allow for the sustained life, recovery, and integrity of Mono Basin ecosystems and for the satisfaction of essential human needs—governs the survival of Mono Lake. Perhaps if we reflect more fully upon ways in which the environmental history of Mono's waters flow into our own ecological destiny, we will be better able to imagine a world in which the ways of water will still reflect the beauties of birds, mountains, clouds, sun, moon, and, stars—and the imaginative spirit of the human soul.

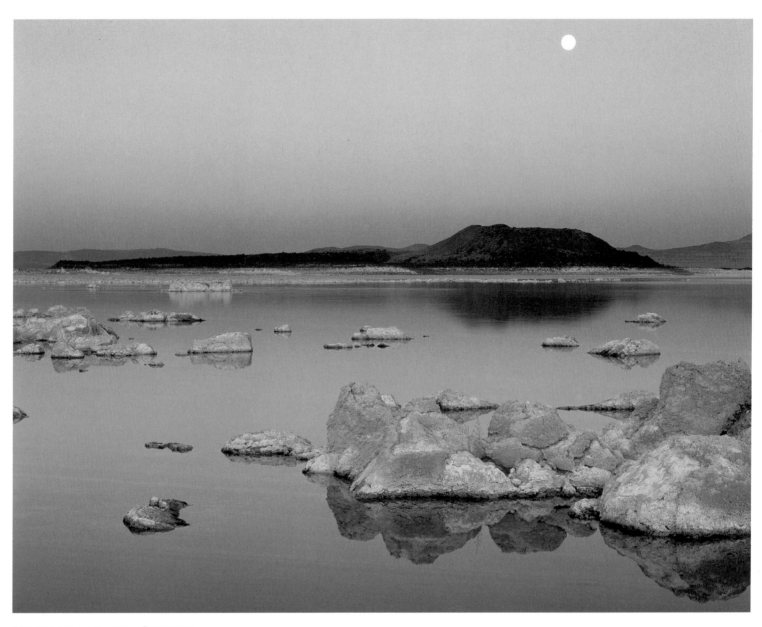

MOONRISE AT SUNSET, OCTOBER

RISING AND FALLING WATERS

At the center of the environmental history of Mono Lake is a story of natural and human-caused shoreline fluctuations. From tremendous shoreline changes caused by the advance and retreat of glaciers and the eruption of volcanoes, to incremental lake level changes specified by current state water laws, environmental and ecological effects of fluctuating shore lines measure and record Mono's story upon the land itself.

Geologists describe Mono Basin as a tectonic depression filled with sediments. About three million years ago faulting of the Sierra's eastern escarpment and downwarping of the basin's north and south sides enclosed Mono Basin leaving no permanent outlet for its waters. Girdled to the north, east, and southeast by the remains of extinct volcanoes—the Bodie Hills, the Anchorite Hills, and the Cowtrack Mountains—hemmed to the south by the more recently active Mono Craters, and walled to the west by the upthrust granite escarpment of the Sierra, the basin has gradually filled with several thousand feet of glacial, erosional, lakebed, and volcanic deposits. Windblown pumice covers much of the area and intermittent eruptions of the Mono Craters during the last 33,000 years give evidence of ongoing tectonic activity in the region.

Throughout the ages melt from massive snow and ice fields of the towering Sierra have wound and cut through piled moraines at the foot of the escarpment or percolated through deposited sediments to reach the low level plain at the basin's center. There, with no avenue through the terrain to continue their seaward

journey, the waters of Mono have always gathered and—like a handmirror held to earth's creation—silently, solemnly reflected ongoing changes in the land.

During Pleistocene periods of glaciation, the basin's prehistoric lake sometimes rose enough to overflow into neighboring valleys through low passes in the encircling mountains. Early morning and late afternoon shadows help reveal ice-age shoreline terraces etched by these inundations high on the hills surrounding Mono Basin. Alternately, the Pleistocene lake sometimes fell to within a few hundred feet of present-day lake levels. Jumbles of lichen-encrusted ice age tufa among sagebrush-covered flats and hillsides surrounding Mono Lake remind hikers that they walk on ancient lake bottom. Within the last six hundred years, continued volcanic activity on the lake floor has also radically altered volume and surface levels of the lake. Paoha Island—formed within the last three centuries—provides spectacular testimony to the relentless power of earth-shaping processes in the basin. Signs inscribed in the terrain of the geomorphic forces that carved and forged the austere grandeur of the basin's landscapes—stories of ice and fire written in sediment and stone—narrate the tale of dramatic lake level fluctuations in Mono Basin's geologic past.

Studies of lakebed sediments in and around Mono Lake provide remarkable insight into the life story of Mono Basin: salt concentrations in sedimentary deposits filling the basin show that while the waters of Mono may have—on extreme occasion—spilled over the bowl of its bounding peaks, lake level fluctuations never resulted in a complete drying of the prehistoric lake. Though the landscape of Mono Basin allows no natural outlet, the waters of Mono have always escaped the basin in significant quantity through evaporation. As evaporated waters of Mono Lake rejoin the greater hydrologic cycle of earth's atmosphere, they leave behind salts and other minerals acquired during their surface and subterranean journeys through the rocks and soils of the basin's watershed. These concentrations of salts accumulated in the lake's waters through the ages intensify as the level and volume of the lake decrease. Because the known sedimentary record of Mono Basin contains no undiluted saline layer, most scientists believe that the Mono Lake we see today is the same continuously living body of water that has occupied this Basin since its formation over 730,000 years ago. Mono Lake is perhaps the oldest living lake in North America and among the oldest lakes in the world.

Lakebed sediments are not, however, the only place where salt concentrations resulting from lake level fluctuations are measured and recorded upon the landscape of Mono Basin. Increased salinity in the waters of Mono resulting from human-caused decreases in the lake's level in recent times has tragically marked the basin's flora and fauna, destroying plant communities in sensitive wetland habitats and reducing numbers and species of breeding and migratory waterfowl.

Since the high water marks and dramatic fluctuations of the Pleistocene ice

ages—but prior to diversion of its streams in the twentieth century—Mono Lake maintained relatively more stable levels with continuing natural fluctuations caused by changes in climate. Prior to stream diversions, the level of Mono Lake fluctuated several feet seasonally with spring floods and summer evaporation. When the City of Los Angeles began diverting water from Mono Lake's inflowing streams in 1941, lake levels declined steadily until 1981, with some small turn-arounds during unusually wet years. After only forty years of diversions from Rush and Lee Vining Creeks the lake level had dropped over forty vertical feet. At this historic low level the lake had shrunk to half its volume, its salinity had doubled, and on windy days thousands of acres of exposed lake bottom fouled pristine mountain skies with caustic, salt-laden dust.

Mono Lake's waters naturally maintain hypersalinity levels of about 5%, double the salinity of the earth's oceans. By 1981 lake level decreases resulting from the diversion of its streams, caused Mono's salinity to rise to 10%. Increased salinity concentrations of this strength severely stressed living organisms of Mono's biologic food web, and researchers warned that further increases of the lake's salinity could threaten the collapse of the basin's entire ecosystem. Mono's hypersalinity and its lack of fish have led many visitors to imagine the lake as a huge, dead, inland sea. However, biologists and closer observers recognize Mono Basin and its lake as a teeming cauldron of biotic productivity. While inhospitable to numbers of diverse species

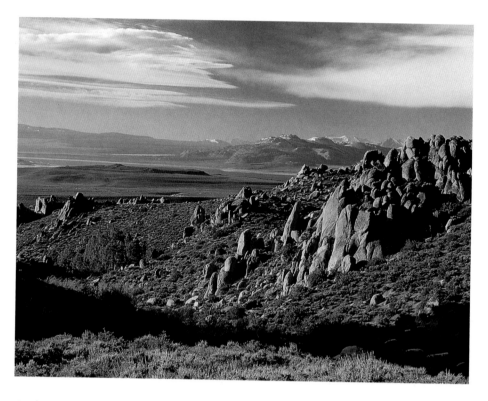

found in fresher water habitats, Mono's waters swarm with staggering populations of unique saline- and alkaline-adapted brine shrimp (*Artemia monica*, a species endemic to Mono Lake) and alkali flies, which provide food for staggering numbers of birds. Without competition from fish, more than seventy species of migratory and nesting birds—including eared grebes, phalaropes, California gulls, and snowy plovers—feed on summer explosions of brine shrimp and alkali fly populations. Mono's brine shrimp may adapt to some increases in salinity over time, but hypersalinity at decreased lake levels has already reduced brine shrimp reproduction significantly and some researchers predict that

MONO BASIN FROM RATTLESNAKE GULCH, JUNE
The Mono Craters and Sierra Nevada Range rise south and west of Mono Lake.

the population could collapse entirely if the lake's salinity reaches 13.3%.

In addition to stresses that increased salinity exerts upon the foundations of the lake's food web, receding waters have had other significant negative impacts on the natural resources of Mono Basin as well. Though effects of salinity on alkali fly populations may be less critical, human-caused fluctuations of the lake's level have seriously degraded and depleted substrate habitats for the fly pupae. Tufa formations exposed by the lake's retreat (perhaps the basin's most scenic attractions) can no longer provide underwater breeding grounds for alkali flies or anchors for their pupae, and tufa formations are themselves made vulnerable to collapse due to wave action at fluctuating lake levels. At the lake's historic low levels, changes in the configuration and character of Mono's shorelines, coupled with dramatic increases in its water's salinity, sent alarming signals of impending ecological catastrophe to scientists, environmentalists, the people of Los Angeles, and the citizens of California.

By 1977, at a surface elevation of 6,375 feet, retreating lake waters had created a land bridge that connected Negit Island with the mainland and jeopardized the largest California Gull rookery in California. By 1979 coyotes crossed the land bridge, routed the entire nesting gull colony, and preyed on eggs and chicks. When the lake level fell to 6,373 feet in 1981, brine shrimp numbers plummeted and nearly all of the gull chicks perished.

Heavy snows in the winters of 1982–83, and again in 1985–86, generated more runoff than Los Angeles could divert, and so the ecological fate of the Mono Basin was held momentarily suspended in a tenuous limbo—a delicate, deadly balance of fluctuating lake levels—as state and federal courts began considerations of what has become one of the most landmark cases in the history of natural resource law. But by that time the spring-fed wetlands that once circled the lake's shore and the riparian woodlands of its desiccated in-flowing streams had suffered devastating degradation; by that time the impressive numbers of ducks, geese, and swans that once flocked the lake's marshy inlets and its surrounding fresh water ponds had largely disappeared. A Pleistocene lake that had endured millennia of geologic and climatic changes hovered on the verge of extinction after only half a century of human "management."

To fully comprehend the scope of human impact upon Mono's destiny, to grasp the significance of social, economic, and political forces that contributed to this moment of ecological crisis, we must consider the role of human imagination in the environmental history of Mono Basin. The waters of Mono have always meant something different to people who have gazed across the lake's surface. What they find reflected there has always, in part, mirrored their imagination of the lake's relationship to their human desires and dreams.

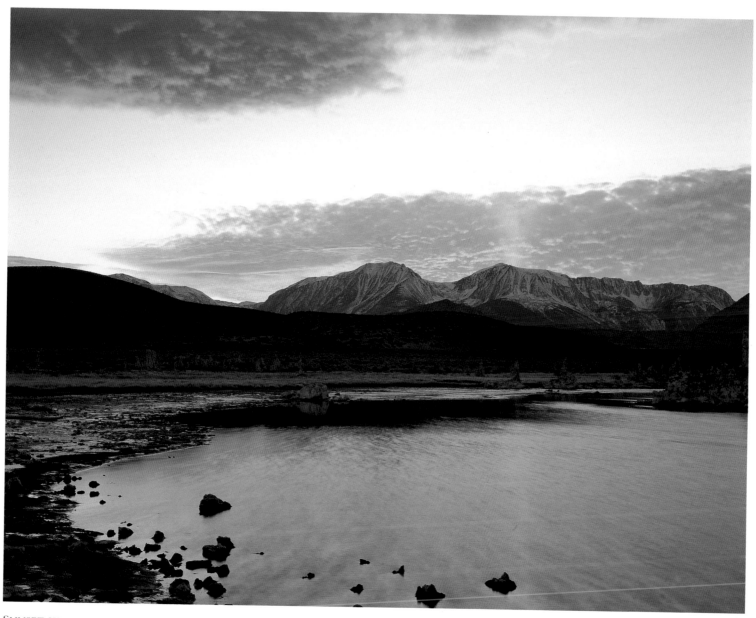

Sunset skies reflected at South Tufa Area, June

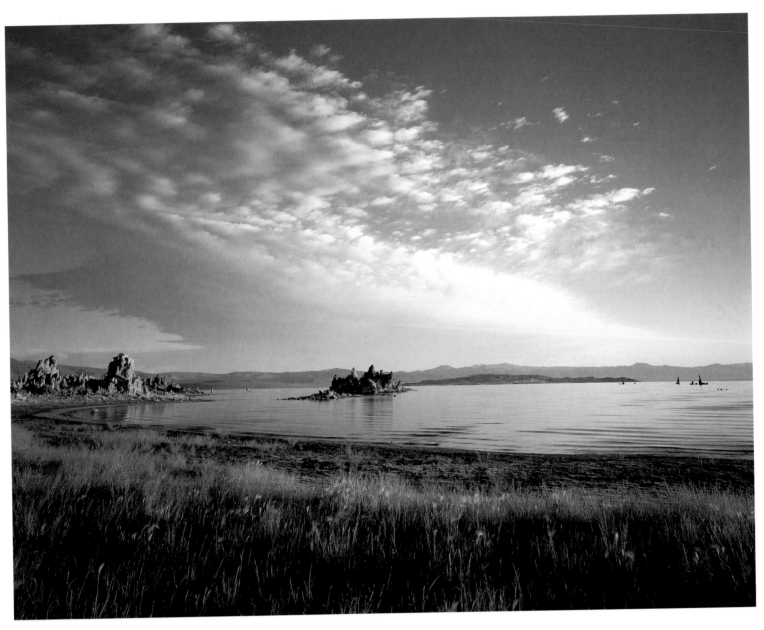

WILD GRASSES AT SOUTH SHORE, JUNE

PEOPLE OF THE WATERS

For the Kuzedika Paiute people encountered by nineteenth-century explorers of the Mono Basin, the waters of the lake, the grasslands of it shorelines, and the forests of its surrounding hillsides supplied life's necessities while the dramatic landscapes of the basin provided settings for tribal stories, myths, and legends.

The Kuzedika—or "fly pupae eaters"—took their name from a mainstay of their diet called *kutsavi*, a food they made from the dried and hulled pupae of the alkali fly. Each fall the women would gather partially dried fly pupae cast up by the lake's waves into long windrows along Mono's shores and winnow away their husks in the wind with specially made, scoop-shaped baskets. The harvest of the pandora moth caterpillars found in the Jeffrey pine forests of the basin's southwestern slopes provided

another important insect food supply, and in the pinyon and juniper woodlands of the basin's northeastern hills, the Kuzedika collected the nutritious nuts of the pinyon pine in their large, conical carrying baskets.

In the sage flats, streambeds, and grasslands surrounding the lake, women gathered berries, herbs, and the seeds of wildrye and other grasses. Young boys trapped lizards and ground squirrels, and stalked the lakeshore and streams for waterfowl. Hunters shot antelope and deer with arrow points knapped from obsidian from the Mono Craters. Annually everyone joined together in communal rabbit drives that supplied the fur for winter blankets and robes. Occasionally, the Kuzedika hauled portions of the basin's bounty in their conical burden baskets over the crest of the Sierra to Yosemite to trade with

23

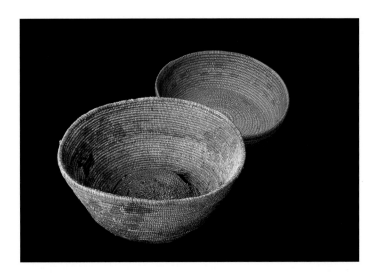

PAIUTE BASKETS, NOVEMBER

*Carefully woven baskets, adorned
with subtle designs, were made by
the native people of the Mono Basin.*

related tribes. Where the first fortune hunters to the basin saw an arid and lifeless, alkali desert sink, the Kuzedika found enough riches in the land to support a population of around two hundred persons for generations upon generations.

Many Kuzedika Paiute were assimilated as laborers and traders in the basin's mining, ranching, farming, and timbering economies during the late nineteenth and early twentieth centuries, and some of their descendants still live in the Mono Basin today. But the indigenous culture of the Kuzedika unraveled rapidly as intrusions of miners and settlers began to unravel the ecology of the region—fencing grasslands, logging forests, and depleting game—until the Kuzedika way of life disappeared along with the bunchgrass, the antelope, and the swans into the basin's past. Their lives— like the intricate, symbolic designs woven into their watertight willow ceremonial cooking baskets—were part of the weft of the natural cycles of the land in which they

lived. Like the complex interdependencies of productive habitats and plentiful species with whom they once shared the basin's ecosystem, the delicate patterns of Kuzedika existence were stressed to the extreme by unrestricted exploitation of the basin's natural resources to fuel boom-and-bust mining cycles of the frontier west.

Though we may know little today of the world view of Mono's original inhabitants, two evocative fragments of their language, *Negit* and *Paoha*, the names of Mono Lake's two volcanic islands, record an imaginative sense of their ancient homeland. Israel C. Russell, the poetic nineteenth-century geologist who first studied Mono Basin and named the islands, called the smaller, darker island Negit for the blue-winged goose that may have once nested there. The larger, lighter island he called Paoha, an invocation of Kuzedika dreams and stories of spirit beings dancing in the mists and vapors of the island's hot springs.

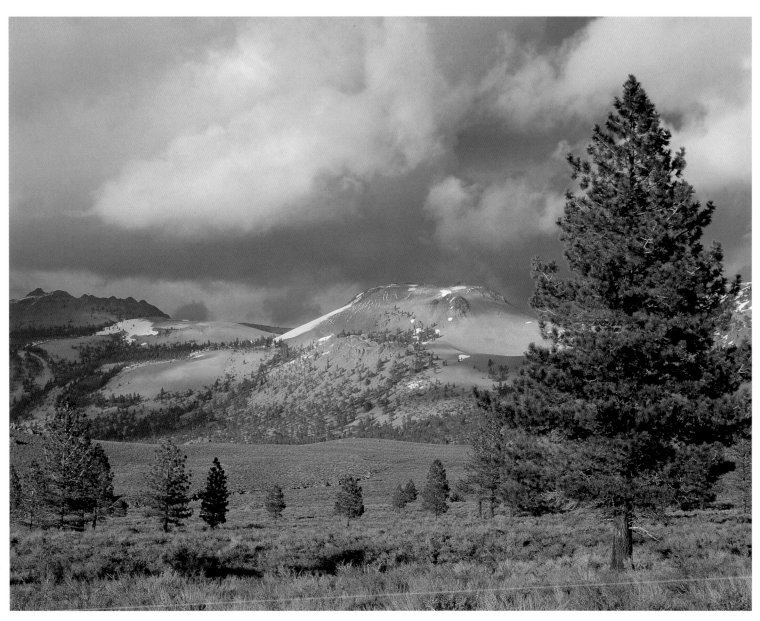

JEFFREY PINE FOREST BELOW MONO CRATERS, MAY

*In forested areas south of Mono Lake, native peoples harvested
Pandora moth caterpillars.*

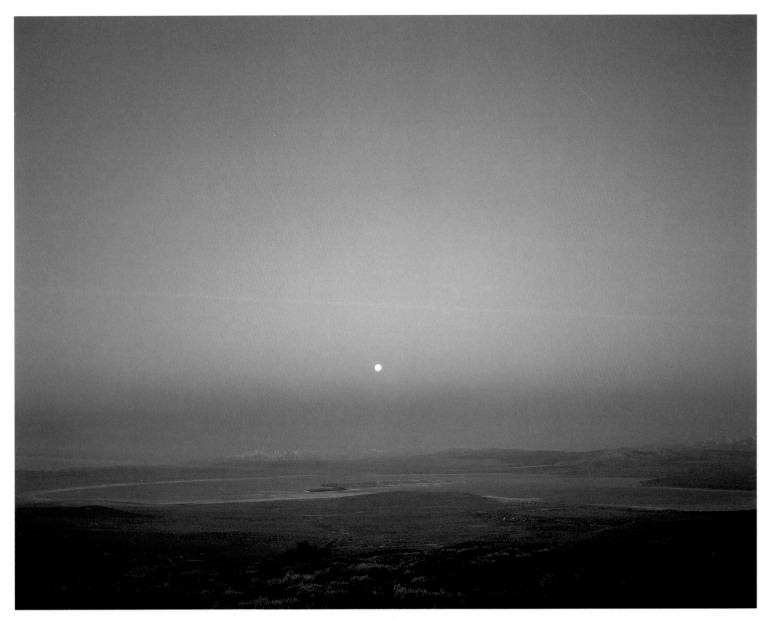

FULL MOON OVER MONO LAKE, JULY

*From above Conway Summit, the view south encompasses Mono Lake
and its islands and islets, the Mono Craters, the Sierra Nevada Range,
and the snow-capped peaks of the White Moutains.*

… after our long wandering in rugged mountains, where so frequently we had met with disappointments, and where the crossing of every ridge displayed some unknown lake or river, we were almost afraid to believe that we were at last to escape into that genial country of which we had heard so many glowing descriptions, and dreaded to find some vast interior lake, whose bitter waters would bring us disappointment.

–JOHN C. FREMONT (1845)

WATERS OF DREAMS

Nearly three centuries following Juan Cabrillo's "discovery" of California for Spain in 1542, the immense Sierra stood untraversed and the desert basin lakes east of the range remained unexplored by Europeans. Through the mission period on the southern and central coasts, through the discovery of gold in the Motherlode country of the western Sierra in 1848, through the brief independence of the Bear Republic, and through the passage of California statehood in 1850, cyclical patterns of Kuzedika life in the Mono Basin continued unaltered by western expansion as they had for generations upon generations. Jedidiah Smith, who first crossed the Sierra from California enroute to Salt Lake in 1827, Joseph Walker, who established the central route across the Sierra in 1833, the first parties of pioneers in the 1840s, and the gold-seeking Forty-Niners all passed north or south of the Mono Basin in their journeys.

John C. Fremont, though he passed somewhat north of Mono Basin itself in 1840, made the first official, scientific expedition to the desert lake basins and the daunting escarpment of the eastern Sierra in the Mono region. As he approached the desert lakes of the eastern Sierra, mythic waters flowed in Fremont's imagination. Legends of a huge, bountiful lake named Lake Buenaventura—which presumably lay at the headwaters of a "Great River" that eventually wound through or around the wall of the Sierra to the Pacific Ocean—had grown for centuries out of the uncharted geography the interior West beyond the Rockies. The hypersaline "terminal" lakes of the eastern Sierra

MONO MILLS, SEPTEMBER
Forested slopes southeast of Mono Lake were harvested for lumber in the late nineteenth century to build the booming mining town of Bodie.

disappointed and frustrated Fremont as expedition supplies ran short and he became increasingly desperate to locate the paradisiacal waters of legend and the promised waterway to the Pacific. Ultimately, Fremont realized that the waters of his imagination belonged to a geography of dreams as he traced the rivers of the interior west to their "deaths" in desert sinks. Realizing that only a phantom river could penetrate the massive Sierra, Fremont gave the name "Great Basin" to the land where the waters failed to find their way to the sea, and his party struggled overland across the crest of the mountains.

After Fremont dismissed the region as arid and declared its waters moribund, interest in the eastern Sierra faded until 1852 when Lieutenant Tredwell Moore led a punitive expedition against Chief Tenaya's band of Yosemite Miwoks across the Sierra and into Mono Basin. Lieutenant Moore returned to Mariposa from his chase across the mountains with samples of gold ore from the basin. As a result of the information and ore samples gathered by Moore's expedition, Mono Lake appeared on subsequent official state maps and the quest for mineral wealth around its shores began. A year following Moore's penetration into the Basin, Leroy Vining led the first party of prospectors into the ancient homelands of the Kuzedika.

Strikes at Dogtown and Monoville brought hundreds to the region. But from the outset of mining operations, the basin's hydrology again proved frustrating. Located along the ephemeral streambeds of the Bodie Hills toward the lake's northwest corner, the placers at Monoville lacked sufficient water. Thus, as early as 1859, ditch projects were already underway to divert the region's water sources to profitable use. The lack of water at Monoville also prompted prospecting elsewhere around the basin and led to strikes at Bodie and Aurora.

The strike in Aurora in 1860 dwarfed developments at Bodie and ended the excitement at Monoville. Just as the buildings of Monoville were torn down and rebuilt a few miles beyond the northeast rim of the basin itself at Aurora, natural resources of the Mono Basin—pinyon pine for cordwood; Jeffrey pine for shaft timbers; gull eggs, waterfowl, and other game for boarding house meals—were shipped to fuel the new growth economy. Meanwhile, the needs of commerce stimulated construction of a wagon road over the Sierra at Sonora Pass and new roads connected timber and ranch operations in neighboring valleys of the eastern Sierra. Roads and demanding markets brought settlers to the Mono Basin, and by 1864 most arable land was already under cultivation.

When the mines at Aurora closed in 1865, miners and merchants vanished from the region. As inflated mining populations dropped drastically, agricultural development continued near streams and springs or on irrigated fields newly cleared of

sagebrush. Stock grazed every available pasturage. After cultural shock generated by the initial waves of miners faded during this relatively pastoral period in the basin's environmental history, the Kuzedika Paiute began—out of necessity—to interact with the new-comers to their land. Driven from their springs and streams, their woodlands lumbered, their game depleted, their grasslands overgrazed by settlers' flocks and herds, the Kuzedika traded venison, pinenuts, baskets, fish and ducks for goods they needed to survive. John Muir observed Kuzedika women harvesting wild rye in 1869, and Israel Russell noted women collecting *kutsavi* near Warm Springs in his Quaternary History of 1889. Eventually the Kuzedika also traded their labor for goods and so the foundations of a local, agricultural economy were firmly in place when another rush—this time for silver—began in 1877 at Bodie.

Again the region's population exploded, and the natural resources of the basin were again taxed by the demands of capital. Sawmill operations in the Bridgeport Valley could not meet the demand for mineshaft timbers and so by 1881 a narrow-gauge railroad was built from Bodie around the east end of Mono Lake to establish an operation at Mono Mills in the extensive Jeffrey pine forests of the basin's southwestern slopes. Destruction of the pinyon forests for cordwood had already deprived the Kuzedika of their extremely important pinenut harvest for winter food stores, and they protested—though futilely—the renewed attacks upon their sacred trees.

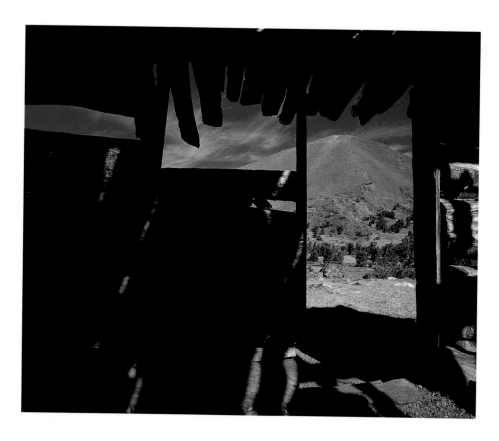

By the end of the nineteenth century, the mining booms had gone bust and the pristine landscapes of the eastern Sierra, known to Europeans for less than half a century, had suffered as much environmental despoliation at the "civilized hands" of the industrial revolution as any other region in America. As the waters of Mono faded once more from the gold-bitten imaginations of men, they now reflected hillsides denuded of forests, canyons scarred by hydraulic mining, and the deserted ruins and ghost towns—the abandoned ephemera of frontier dreams—in the ancient homeland of the Kuzedika.

CABIN AT MONO PASS, OCTOBER

During the mining days of the nineteenth century, supplies were brought by wagon to a supply station at Mono Pass high in the Sierra Nevada, then carried by pack animals down steep and rugged Bloody Canyon to the Mono Basin.

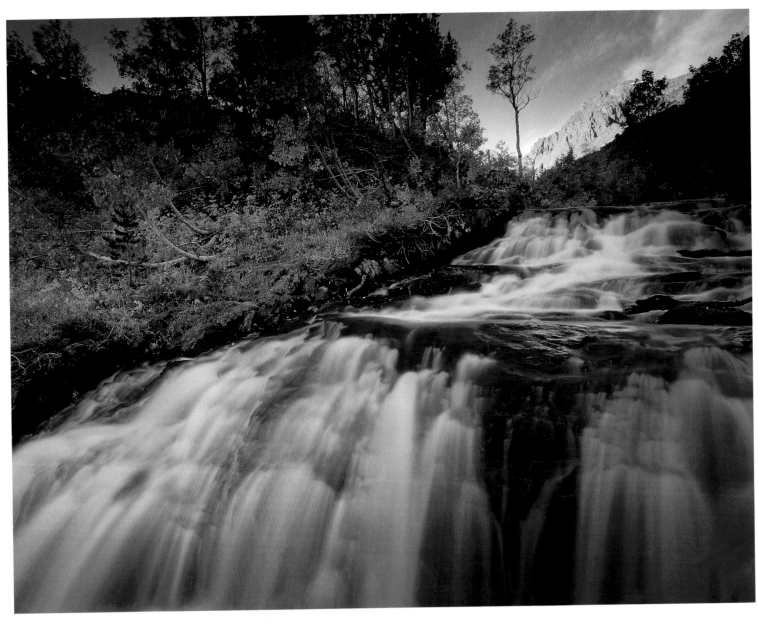

MILL CREEK, OCTOBER
One of Mono Lake's main tributaries, cascading Mill Creek
rushes through Lundy Canyon.

IN QUEST OF WATERS

With the turn into the twentieth century, however, Mono's waters did not lay neglected nor undisturbed long. As irrigation for agriculture in California's central valleys launched new bonanzas, and as metropolitan growth in coastal cities—San Francisco, Los Angeles, San Diego—expanded exponentially, the Golden State's economies began to realize the true wealth of the Sierra. Neither the magnificent extractable mineral wealth of the Sierra's gold and silver ores, nor the record timber yields of its expansive forests, nor the bounty of its flocks, herds, and farmlands would outmeasure the inestimable riches that would flow from control of its water resources.

As metropolitan life in the coastal cities became increasingly urban, Californians began to find significant recreational values in the rustic landscapes of the eastern Sierra. Its lakes and streams began to fill a growing thirst for relaxation, contemplation, and adventure as an antidote to strains and stresses of modern city life. Once imagined as lifeless and useless, the waters of Mono Lake were promoted for their therapeutic values to growing health and tourist markets. Spas and bathhouses arose along its shores, its salts were bottled as patent medicine, and sightseers visited freshwater lakelets on Paoha Island. Recreational fishing, hunting, and camping developed into tourist industries in the region. The dramatic land of Mono—a land of volcanic craters and cinder cones, a land of an ancient inland sea and strange tufa towers, of cloud-raking peaks and desert vastnesses—has long elicited varied, but always strong, responses from visitors.

Contrasting images of Mono Basin written by two earlier travelers to the region dramatize the transformation of Mono's landscapes from wasteland to tourist destination in the popular imagination.

In *Roughing It*, published in 1872, Mark Twain emphasized the starkness of the terrain. He found the lake "little graced with the picturesque" and described its surrounding landscape as "a lifeless, treeless, hideous desert." He called Mono Lake a "solemn, silent, sailless sea" and declared it "the loneliest tenant of the loneliest spot on earth." In contrast, Israel Russell, exploring the Mono Basin for the United States Geological Survey in 1883, discovered much scenic worth apparently missed by Twain in the landscape.

According to Russell, who later helped to create the National Geographic Society, "few journeys of equal length could present greater diversity in all the elements of scenery than a single summer day's ride from the parched and desert plains bordering Lake Mono on the north, to the crest of the mountain mass that fills the horizon to the west and southwest of the lake." Russell surveyed an enticing landscape of radically contrasting formations and habitats. At one end of the basin he found magnificent mountains "clothed in favored places with forests of pine" reaching far above the timber line and bearing "a varied and beautiful Alpine flora." Here, Russell heard the constant "rush of creeks and rills" from "the canyons that descend from the snow fields and miniature glaciers about the summits." To the east of the Sierra's escarpment Russell found a stimu-lating contrast in the parched aridity of the Great Basin. The land of Mono, Russell wrote, contains the "fragments of two distinct geographic provinces. One has the desolation of the Sahara, the other the rugged grandeur of the Pyrenees."

Therapeutic, recreational, and scenic values of Mono's landscapes and waters could not compare, however, with the value of the basin's hydrology to the plumbing of California's suburban developments and to the growth of its massive irrigation projects dreamed by investors, politicians, and planners. Not long after the City of Los Angeles had engineered a 240-mile aqueduct to drain the waters from the elevated basin of Owens Valley to its sea-level consumers, the quest to control the waters of Mono began in earnest. Completion of the Owens Valley aqueduct in 1913 only whetted the City's thirst, further stimulating its suburban sprawl and spreading irrigated orchards and agriculture into the San Fernando Valley. If Fremont's dreams of a navigable passage from the desert lakes of the eastern Sierra to the coast had proved phantasmal, perhaps human imagination and engineering could yet supply what nature had withheld. It did not take long for developers and managers of the Owens Valley aqueduct projects to imagine a course for a pipeline tunneled through the Mono Craters to tap the even higher watershed of Mono Basin and add even more volume and hydrologic power to their expanding regional grid.

As Los Angeles competed with San Diego and other cities—as well as with

local interests—in the quest to control Mono's waters, images of Mono Lake as a dead, inland sea again acquired peculiar currency. Characterizing the lake as a lifeless alkali waste, the City proposed its plan to divert Mono's streams into its Owens Valley aqueduct system as a reclamation project to "salvage the water in Mono Basin being lost in the saline waters of Mono Lake." During the era of reclamation that saw huge dam and water projects erected throughout the West in the first half of the twentieth century, a doctrinal dream of hydrological engineers (also popular in the public imagination) was to halt the flow of unused fresh water rivers to the "unusable" seas. The doctrine that no unused fresh water be allowed to flow to the sea—which later met its first critical challenge in the history of natural resource law through the Wild and Scenic Rivers Act of 1964—was imagined by analogy to apply equally to the streams and inland sea of Mono Basin.

In 1930 the city's voters approved a $38-million bond issue to lengthen the Owens Valley aqueduct system into Mono Basin. The City of Los Angeles brought suits condemning local property and water rights that forced the basin's farmers and residents to sell out. In 1941, after six years of difficult labor with a work force of up to 1,800 men, a completed tunnel extending the length of the City's pipeline to 338 miles began to drain the waters of Mono. A "second barrel" pipeline begun in 1963 and completed in 1970 increased the drain by another 50%. Ironically, as the City extended its practice of acquiring land and water rights in the eastern Sierra from Owens Valley into Mono Basin, it also had extended the basis for an ongoing relationship between recreational interests and water use issues in the region's environmental history.

As the City's exploitation of the region's water resources foreclosed potentials for other types of agricultural, residential, or industrial development rampant elsewhere throughout the state, the landscapes of Mono lake increased in their scenic, wilderness, and recreational values. Skiing, hiking, camping, fishing, birdwatching, hunting, boating, swimming, bicycling, mountain-climbing and the apparently essential need for humans to simply experience and contemplate natural processes in the sublime beauty of snowy crags and pristine waters had brought hundreds of thousands of enthusiasts and appreciative visitors to the relatively undeveloped eastern Sierra. Therefore, when stream diversions brought the lake to the verge of an ecological nightmare by 1981, scientists, environmentalists, the people of Los Angeles, the citizens of California, and concerned people everywhere refused to imagine such environmental devastation as acceptable. Now a new quest—the quest to save the waters of Mono—demanded the concern, the attention, and the very best energies of an emerging ecological imagination: an imagination capable of embracing needs and requirements of human communities and natural ecosystems in dreams of a healthier world.

LUNDY CANYON, AUGUST
Rabbitbrush blooms on hillsides above Mill Creek in one of Mono Lake's major tributary canyons.

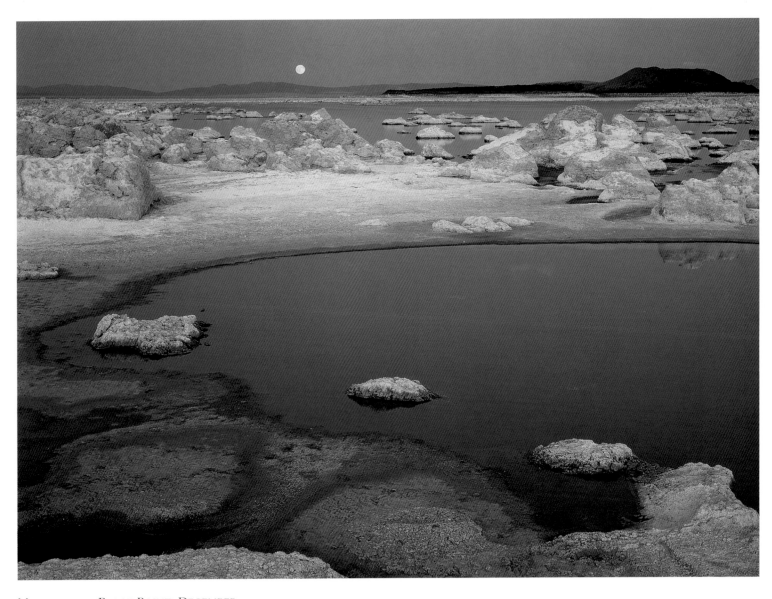

Moonrise at Black Point, December

34

SAVING THE WATERS

During the 1960s, the twin lakelets on Paoha Island once fed by seepage of Mono's waters through the island's porous sediments dried into salt pans as the lake receded. Springs around the shoreline slowed and disappeared. After the City of Los Angeles opened the "second barrel" of its Mono Basin pipelines in 1970, lake levels began dropping steadily a foot or more a year as evaporation outmeasured stream flow. Airborne particulates from miles of exposed lake bottom polluted the region's atmosphere in violation of Federal Air Quality Standards. In 1976 a group of scientists and graduate students from the University of California and the Point Reyes Bird Observatory received National Science Foundation funding to study unique habitats and species of the Mono Basin. The researchers found alarming evidence of a vital ecosystem on the verge of collapse. Two years later, in 1978, ornithologist David Gaines joined together with scientific colleagues from the Mono Lake research team and concerned environmentalists to form the Mono Lake Committee and lead the effort to save the waters of Mono.

The next year, 1979, as coyotes crossed the newly exposed land bridge to Negit Island and forced gull colonies to relocate to smaller islets, the Mono Lake Committee filed suit jointly with the National Audubon Society and Friends of the Earth to stop the tragedy caused by diversion of Mono's streams. The legal history of this suit reflects more than a hopeful victory—at least as I write—in the struggle to save Mono Lake: it also reflects a landmark development of legal principles

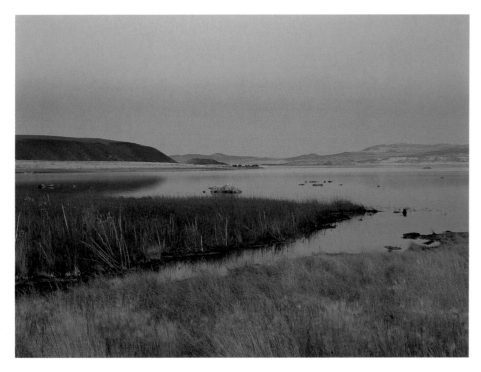

TWILIGHT, OCTOBER

Wetlands near County Park on Mono Lake's northwest shore provide habitat for birds and wildlife.

addition of discretionary responsibility to the SWRCB's administrative functions. The SWRCB became responsible for determing that water use permits served the public interest. Subsequently, state water law has broadened definition of the public interest to embrace in-stream values of the state's waters. That is, contrary to the hydrological myths of manifest destiny that drove an era of reclamation, natural resource law now expressed a public interest in the value of some waters— wild and scenic rivers, estuary wetlands, and sensitive riparian habitats—flowing "unused" and undisturbed to the seas.

Concurrent with legislated extensions of the SWRCB's responsibilities to the public interest, a growing body of state and federal case law extending common law traditions of the public trust began to influence natural resource law through the courts. As early as 1885, the California Supreme Court decided a public trust case—*The People vs. The Gold Run Ditch Mining Company*—against a hydraulic mining operation that contributed to navigational hazards on the Sacramento and American Rivers. The decision extended the traditional English Common Law applications of public trust protection to navigable harbors and tidal rivers to California's nontidal waterways. While early public trust cases concerned navigation, commercial, and fishery values of the state's waterways, a 1971 California Supreme Court Decision—*Mark vs. Whitney*—further extended the legal concept of the public trust to include protection of an ecological preserve.

of the public interest and public trust in natural resource law.

Under the statutory system of appropriative rights that governs California state water law, an administrative state agency, the State Water Resources Control Board (SWRCB), allocates rights to store and divert water for beneficial use in the public interest. According to common law traditions governing natural resource law, water itself never becomes transferable property; only the privilege to "use" water may be permitted or licensed. Initially the SWRCB simply determined administratively whether "unappropriated" water resources were in fact available to permit applicants. In a 1928 amendment to the state constitution, the legislature authorized the

Two cases in 1981 applied public trust values to nontidal, submerged lands of Lake Tahoe and Clear Lake. That same year, as Mono Lake reached historic low levels, California established the Mono Lake Tufa State Reserve to protect formations exposed by the lake's receding waters.

A landmark development of the concepts of the public interest and public trust in natural resource law occurred early in 1983 when the California Supreme Court first decided on the landmark case known officially as *National Audubon Society vs. The City of Los Angeles*. The court concluded that public trust protection applied to the ecological values of Mono Lake. Following the State Supreme Court's Public Trust Judgment, lower courts mandated the return of minimum flows to Rush Creek in 1984 and to Lee Vining Creek in 1987 to preserve below-diversion trout fisheries pending final settlement of the *National Audubon* case.

On September 28, 1984, public interest in the Mono Lake controversy received further legislative definition and support when Congress established the Mono Basin National Forest Scenic Area. The legislation required the U.S. Forest Service to develop a Comprehensive Management Plan for the Scenic Area to protect its ecological, geological, cultural, and scenic resources. The Forest Service plan—based upon the National Academy of Sciences 1987 report, *The Mono Basin Ecosystem: Effects of Changing Lake Level*—recommended a range of lake levels necessary to protect the basin's scenic and ecological resources. Managers selected upper levels

to protect snowy plover habitat, to preserve wetlands, and to protect tufa. But by 1989, Mono Lake had dropped well below the plan's minimum recommendation.

That same year, after six years of continued proceedings, the courts ultimately remanded the *National Audubon* case to the SWRCB and required the board to redefine Los Angeles' water rights and to balance municipal uses of Mono's waters with public trust values served by maintaining stream flows into the lake. Charged legislatively to serve public interests by allocating *and* protecting the state's waters, and instructed by state and federal courts to balance values of an ecosystem with a city's needs, the SWRCB began a lengthy consideration and environmental assessment of the complexities of the Mono Lake controversy.

In June of 1993, the State Water Re-sources Control Board released the draft *Mono Basin Environmental Impact Report* (EIR) which served as a basis to review and modify the Department of Water and Power's rights in the Mono Basin. In response to the draft EIR, the Forest Service also reviewed its recommended lake level in light of new information regarding air quality, snowy plover habitat, and lake brine shrimp productivity. In late 1993, extreme dust storms prompted the Environmental Protection Agency to list the Mono Basin in violation of the Clean Air Act. Days before the SWRCB would release its court-ordered, public trust decision, the Governor of California signed legislation providing state funds for construction of water reclamation facilities in

Los Angeles. The Federal Bureau of Reclamation also reaffirmed its commitment to develop 135,000 acre-feet-per-year of replacement water supplies for the Los Angeles region. Historically, diversions from Mono Basin averaged below 100,000 acre-feet. Through reclaimed water projects and conservation, Los Angeles could create a larger drought-proof water supply than needed to replace the water it would "lose" by halting diversions from Mono Lake! As a result of innovative water conservation measures, a SWRCB decision to protect ecological public trust values at Mono Lake would not create new pressures on the San Francisco Bay Delta or other California water resources.

Finally, on September 28, 1994—the tenth anniversary of the creation of the Mono Basin Scenic Area, and nearly a dozen years after the California Supreme Court's public trust judgment—the State Water Resources Control Board released a decision regarding Mono Lake. In a win-win judgment for Mono Basin's ecosystem and for the people of Los Angeles, all involved parties accepted—in a spirit of cooperation—the SWRCB's order to increase the lake level to an elevation of 6,392 feet above sea level. The mandated lake level is seventeen feet higher than in 1994, but twenty-five feet lower than in 1941 when diversions began. Depending on the amount of rainfall and snow melt flowing from its tributary creeks, it may take twenty to thirty years for Mono Lake to reach the 6,392-foot level.

Two years earlier, in the summer of 1992, the Mono Basin Scenic Area Visitor Center—dedicated to the memory of David Gaines—had opened to the public. After nearly a dozen years as a "reluctant warrior" in the struggle to save Mono Lake—giving speeches, slide shows and testimony, and writing articles that promoted scientific research, publicized issues, and raised funds in defense of the basin's ecosystem—David was killed in an automobile accident during a winter storm on January 11, 1988. Each year hundreds of thousands of new and returning visitors to Mono Lake gaze across the surface of its ever-changing waters from the observation room and patios of the Visitor Center and reflect upon the environmental, human, and legal histories—and still uncertain future—of the lake's delicate survival. They are also reminded of the powerful dreams of the gentle ornithologist who imagined that in the ongoing effort to save and restore Mono Lake, "We should think of ourselves not as fighters, but as healers."

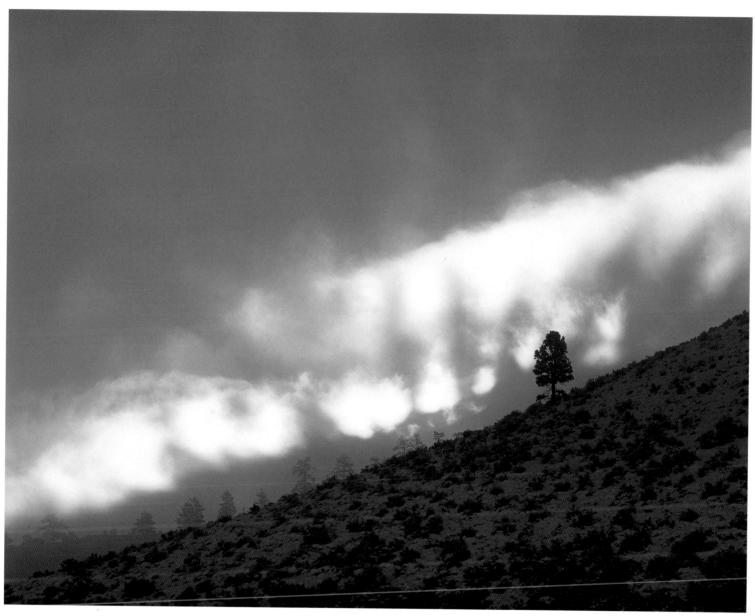

POCONIP FOG, DECEMBER
Sun rises behind a hillside veiled in icy fog.

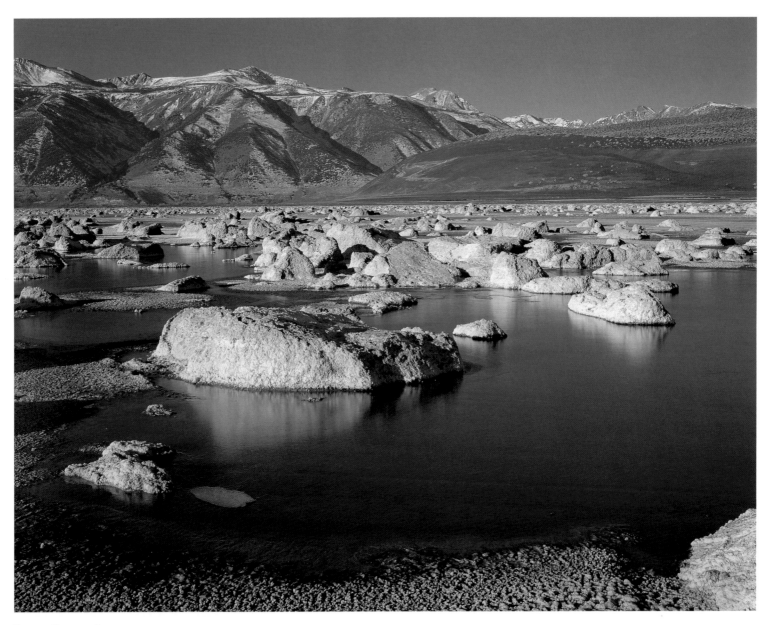

BLACK POINT, JUNE
Tufa-covered volcanic rocks rest along the shoreline of Mono Lake.

*As Rush Creek and I rambled to Mono Lake,
I was struck with how quickly Mother Nature,
given the chance, heals the wounds we inflict upon
her. If Nature can heal an injured land, it can heal
our blighted souls as well. That's why saving Mono
Lake is a matter of saving and healing ourselves.*

—DAVID GAINES, *Mono Lake Newsletter*

HEALING THE WATERS

The winter of 1995 brought record-breaking snow loads to the Sierra Nevada, and late-season storms ensured a strong pack and a long summer melt. That July 4th weekend when I set out to seek the headwaters of Rush Creek, the snow-clad crest blazed white with preternatural brilliance in Mono's burnished waters beneath an overhead, mid-summer sun. Snowfields slowed my progress even before I reached the still-frozen lakes of the upper Mt. Lyell drainage and melting snowbridges and overhanging banks complicated stream crossings. I made camp on a southwest slope above the cascading deluge of a still-snowbound Rush Creek and listened to the music of Mono's rebirth. Somehow I imagined the waters singing to themselves, as if they somehow knew they flowed homeward once more and so flooded in riotous profusions through the watershed and sang of a filling lake.

A couple of weeks later, the waters of Mono Lake reflected an impressive snow-pack still closing the high passes and still feeding the basin's flooding streams as I paddled one morning along the south-western shoreline from Navy Beach toward the mouth of Rush Creek. Rising waters had radically altered the lake's shoreline already, and I paddled around tufa formations illuminated by reflecting surface ripples where I had walked last fall: I imagine the lake healing.

Shoals of sediment form a submerged delta where the fresh water of Rush Creek joins the salinity of the lake. California gulls congregate here; they stand in thick numbers upon the alluvial sediments deposited by the creek and let the freshwater ripples

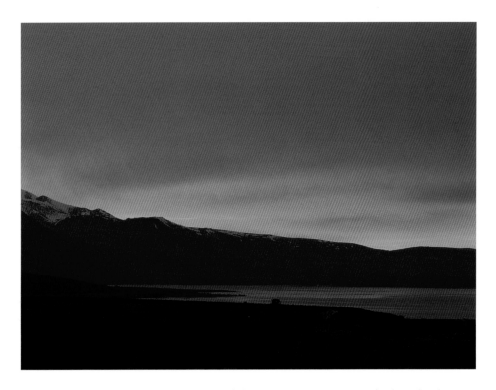

SOUTH SHORE, DECEMBER
*Every sunset casts subtle variations
of twilight colors over Mono Lake.*

called "meromixis"—such as occurred in 1983? How will another episode of meromixis affect the long-term balances of the lake's seasonal thermal and chemical cycling with reproductive cycles of brine shrimp populations? Will we successfully restore willows and aspens and pines to the eroded channel of Rush Creek? Will we see the return of ducks and geese and swans and ospreys—together with grebes and gulls and plovers and phalaropes—to Mono's shorelines? As I paddle on, I trace the line of Lee Vining Creek's more vegetated riparian streambed across the sage flats below the new Mono Basin Scenic Area Visitor Center, and I imagine Rush Creek healing.

On the return crossing, the day is still cloudless and the surface of the water lies utterly calm. Tufts of downy gull feathers float dreamily like dandelion fluff on a lazy summer breeze, and yellow rafts of *Juncus* pollen stream in motionless ribbons upon the motionless water. I rest from my paddling for some moments in mid-crossing and hunker in the provisional shade of my umbrella as the mid-day sun hovers overhead. Only the movement of birds—the cry or splash of a gull, the sleek dive or running lift-off of a grebe—breaks the stillness. I sit becalmed "as a painted ship upon a painted ocean" upon the glazed surface of a huge mirror lying at the bottom of a magnificent mountain bowl, and I begin to reflect.

From the lake's surface, the perimeter of the basin forms the visible horizons in every direction; from this vantage I can imagine the entire watershed and envision

of the entering stream wash their bodies of accumulated lake salts. Near the delta, a congregation of gulls lift off, circle in noisy gyres, and then return to the cleansing shoals. I paddle past chunks of floating pumice washed into the lake by the flooded stream.

I imagine the tremendous influx of the basin's waters into the lake following so fortuitously upon the SWRCB's restored lake level decision as Nature's blessing upon our growing public acceptance of ecological responsibility. But I also have continued concern about the lake's restoration and survival. Will the record snow melt of the last season flood the surface of Mono Lake with a floating layer of less saline water—a chemical stratification

a complete hydrologic system. Below the surface, swarms of brine shrimp—their tiny bodies glints of refracted sunlight swirling slowly in kaleidoscopic patterns—shimmer hypnotically. I turn from the encircling peaks and ridges and use my pocket monocular to stare underwater into the center of the basin's food web. Magnified to monstrous scale and weirdly beautiful in my loupe, flocks of feathery-bodied, bug-eyed shrimp browse on blooming algae pastures. From this vantage I imagine the heart of the basin's chain of life and envision a complete ecosystem. Only twenty to thirty miles across in most places, with a uniquely simple and fecund ecosystem at its center, the Mono Basin provides an almost ideal living laboratory for the ecological imagination. Here natural processes dramatically define the environment; here human influences upon those processes are distinctly drawn. Here I imagine a healing of more than Mono's lakes and streams; here I imagine a healing of our human souls as well.

What will restoration and healing of Mono Lake require of us? Will historic court and legislative victories that have secured the renewal I see this day withstand future legal challenges? Do the rising waters I see signify a turning point in the environmental history of Mono Lake, the beginning of its lasting recovery and survival? Or will this season's floods represent only a temporary fluctuation of the lake's levels as hard-won gains are reversed in turning political tides? As I resume my journey shoreward, I am aware of a crisis in our nation's environmental history: twenty five

years of protective natural resource law—including the National Environmental Protection Act, the Endangered Species Act, the Clean Air Act, and the Clean Water Act—face hostile scrutiny in Congress this year. I try to imagine what it will take to heal the alienation that persists between people and our planet.

Mono's continued survival inspires me with the hope that an emerging ecological imagination will yet discover answers to these and other more vexing questions: that through concerned and creative contemplation of the life-sustaining relationships between people and places and wild things we can discover ways to form consensus and community instead of hostility and conflict around ecological issues; that we can envision laws that protect both people and natural resources from effects of environmental degradation; that we can imagine a public trust wherein the rights to enjoy benefits of a healthy natural world are extended to all; and that, finally, we can begin to imagine extending rights of reciprocity and respect to all living things—species, habitats, and eco-systems—with whom we share our world.

The environmental history of Mono Lake mirrors our imagination of our relations—actual and mythic—to the natural. It reflects our historic inabilities and abilities to imagine right relations with the planet we occupy, and it speaks to us of what we might become if we begin to learn from what Mono's reluctant waters show us. In the mirror of Mono Lake we discern the outlines of its and our own ecological destinies, interdependent

The birds and animals, trees and grass, rocks, water and wind are our allies. They awaken our senses, rouse our passions, renew our spirits and fill us with vision, courage, and joy…We are Mono Lake.

–DAVID GAINES, *Mono Lake Newsletter*

destinies ultimately dependent upon our willingness to imagine more sustainable forms of human and environmental interconnectedness in the ecology of the world. In the waters of Mono Lake shimmer the potential of a powerful expression of human spirit, the promise of a creative, problem-solving, freedom-seeking, world-renewing ecological imagination. The necessity for such an ever-deepening imagination confronts us each time we gaze across the lake's surface and contemplate the significance of its survival. Our capacity to imagine a living Mono Lake grows in the instant we recognize the realities its receding waters have shown us and accept the responsibilities its continued life requires of us. And somehow—as the towering, cloud-draped Sierra leaps in its reflective surface, as rich cycles of life teem in its depths and on its margins—we may come to imagine and perhaps even acknowledge the metaphoric face in the mirror of Mono as our own.

At the water's edge I look once more into the lake and meet an image I somehow hadn't noticed earlier. There, projected upon the reflected alpine skies of Mono Basin, I see myself looking back at me. Stepping ashore, I imagine myself healing.

–*Mark A. Schlenz*, January, 1996

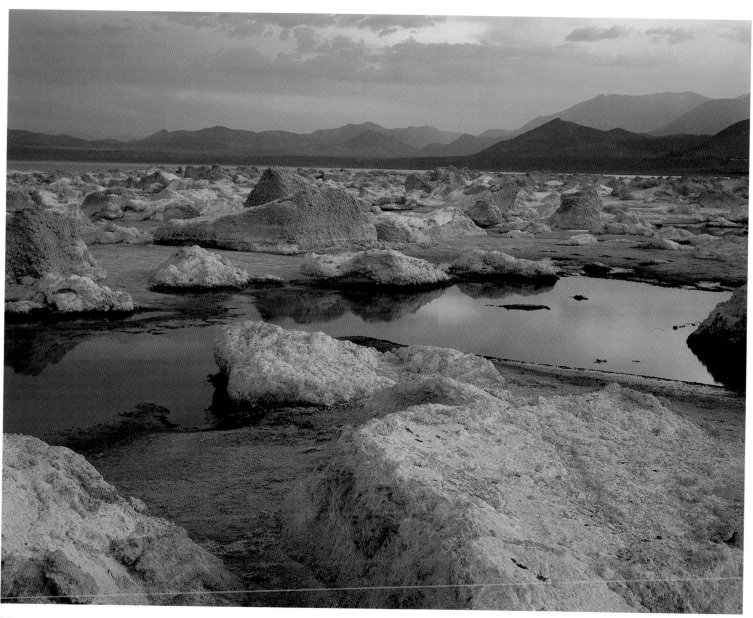

NORTH SHORE SUNSET, JANUARY

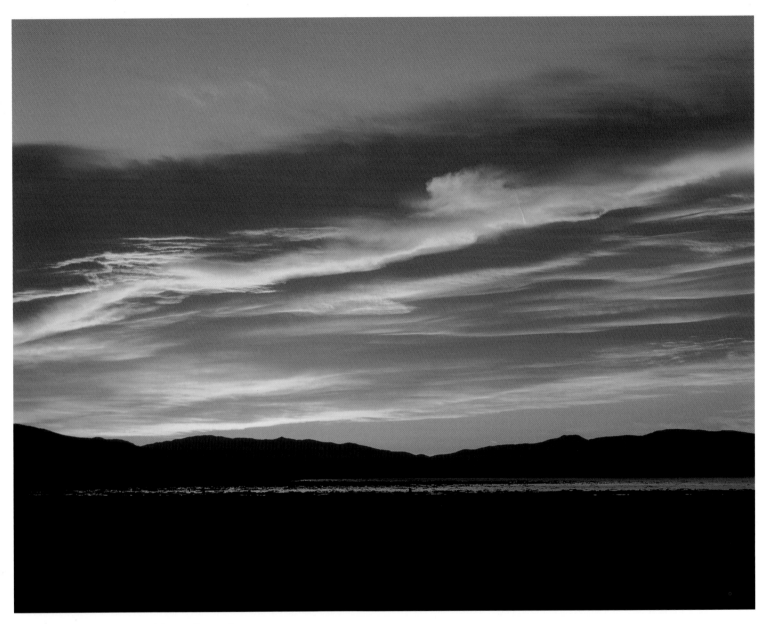

Pre-dawn skies east of Mono Lake, June

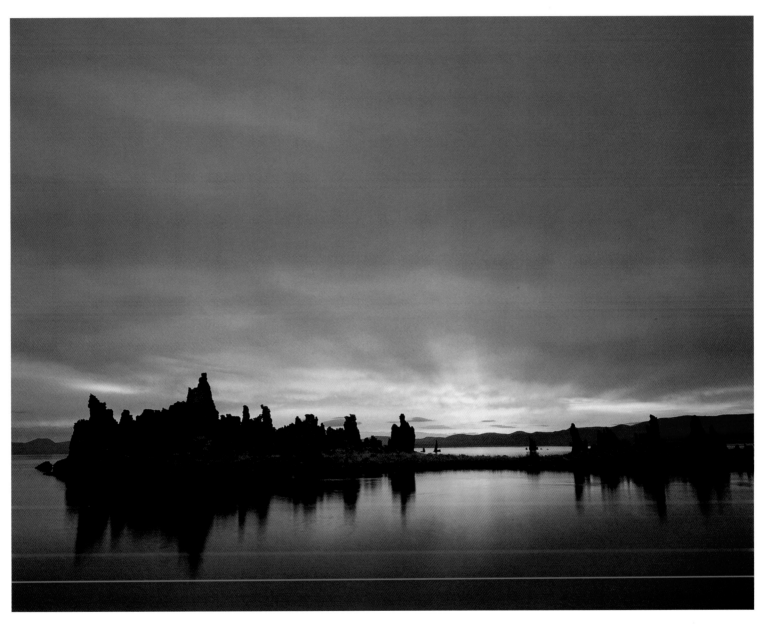

SUNRISE AT SOUTH TUFA AREA, MARCH

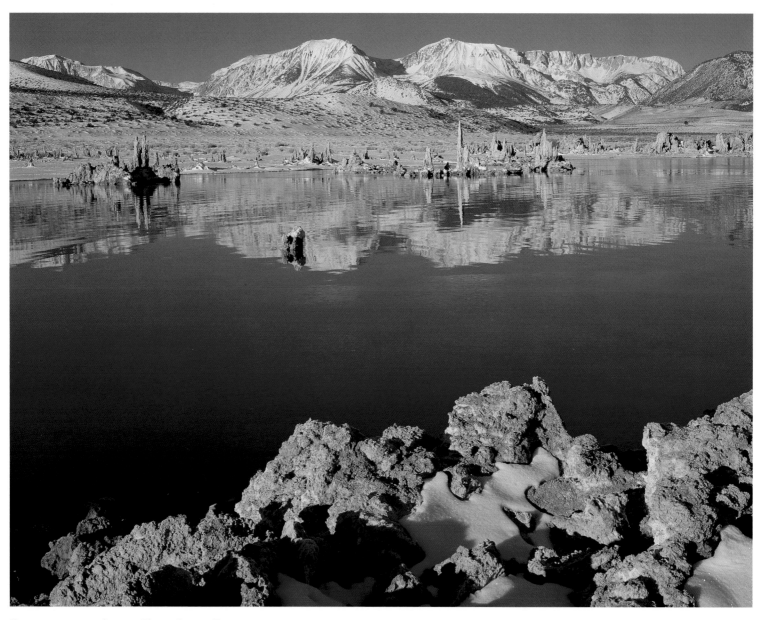

FRESH SNOW AT SOUTH TUFA AREA, FEBRUARY

Tufa forms underwater when calcium-bearing freshwater springs well from below the surface of Mono Lake's alkaline waters. When lake waters recede tufa towers, spires, and boulders are exposed to view.

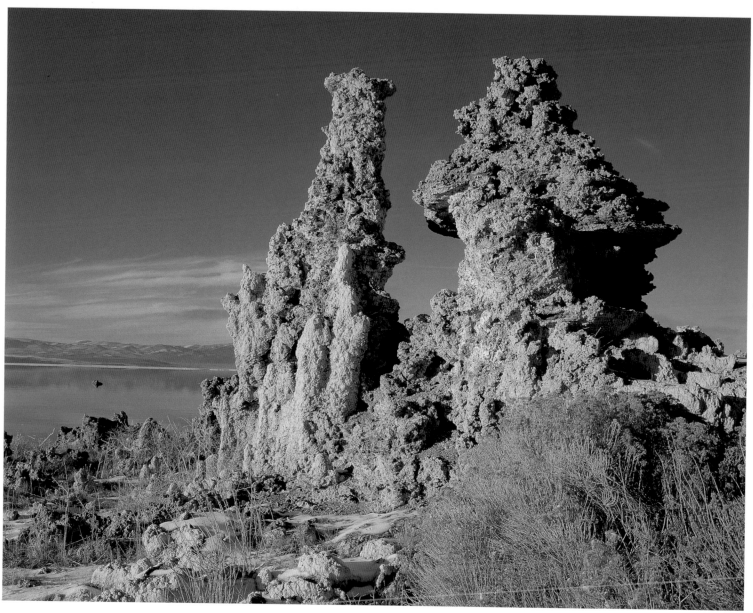

TUFA TOWERS, DECEMBER

Shelf-like sides of some tufa formations were created after the tower's top was exposed, and fresh springwater continued to flow down its sides to react with the alkaline lake waters.

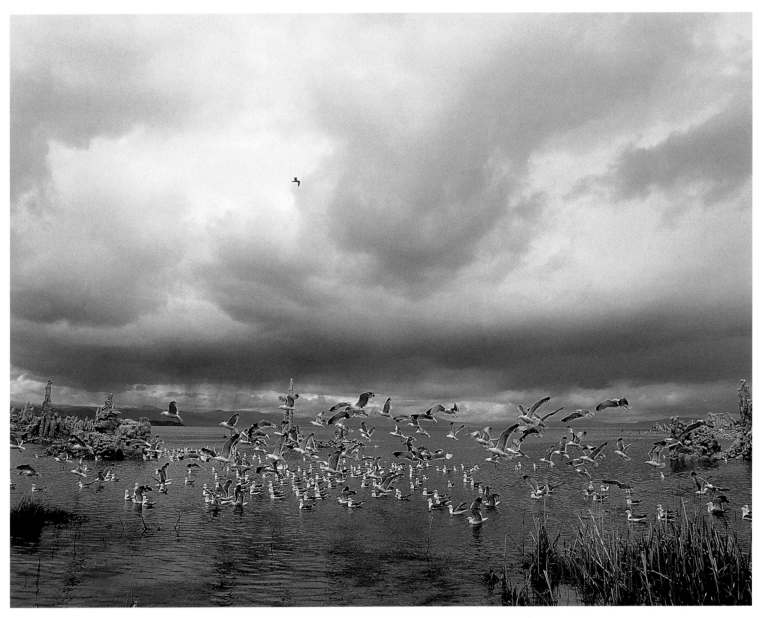

CALIFORNIA GULLS AT SOUTH TUFA AREA, MAY

Thousands of California gulls flock to Mono Lake each spring to feed on its abundant brine shrimp and nest on its islands and islets. Over 80% of the California population of this gull species hatched at Mono Lake.

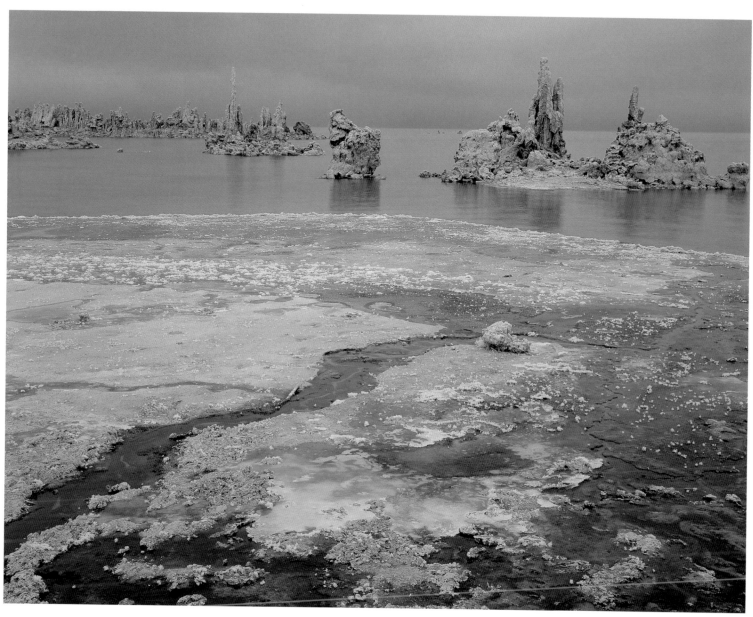

ICE CRYSTALS ALONG SHORELINE, JANUARY

Mono Lake's food chain begins with green algae, a microscopic one-celled plant.
In winter, when algae blooms, lake waters can take on a greenish cast.

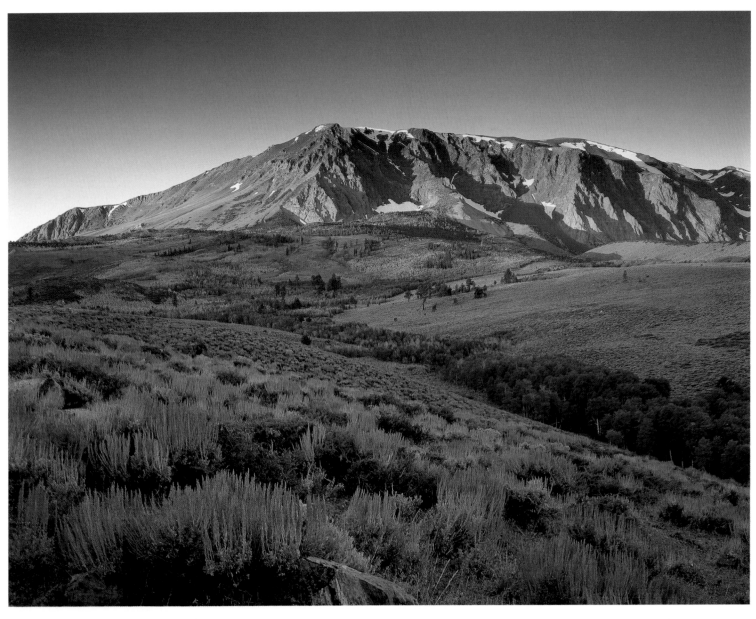

Morning glow on the Sierra, September

Watershed from the Parker Bench drains into Rush one of Creek, Mono Lake's major tributaries.

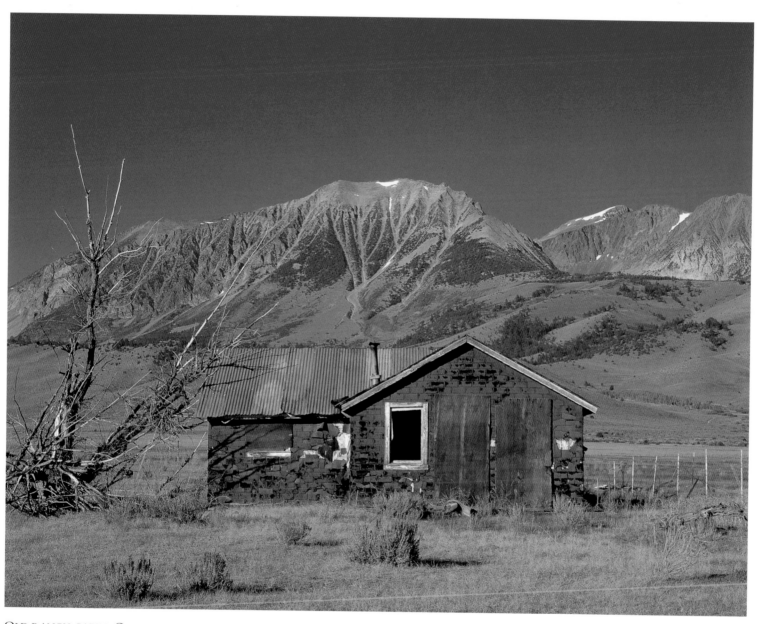

OLD RANCH CABIN, OCTOBER

North of Walker Creek stands a rustic reminder of Mono Basin's early 20th century ranching history.

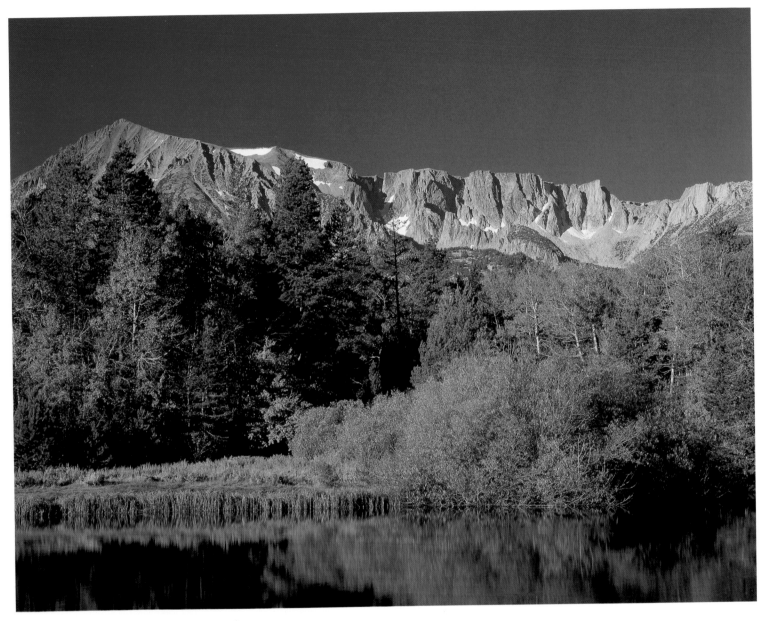

MT. DANA FROM LEE VINING CANYON, OCTOBER

Fall colors line Lee Vining Canyon and a diverted pool of Lee Vining Creek. The canyon, creek, and nearby town were named for early prospector Leroy Vining, who came to the Mono Basin in 1853.

FOREST FLOOR FOLIAGE NEAR MONO PASS, OCTOBER

The forest colors of the mountain passes change in the brief weeks before the winter snows.

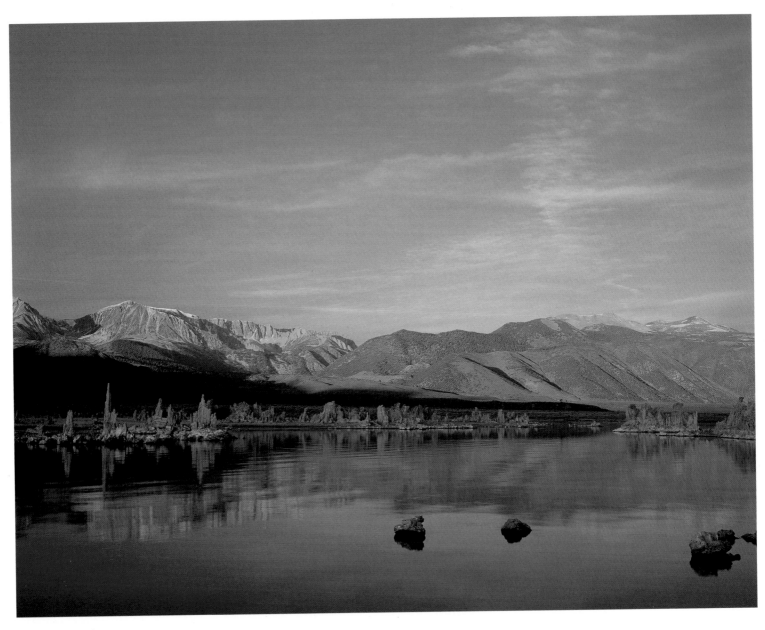

FIRST LIGHT, APRIL

Mt. Dana (elevation 13,053 feet) and ridges of the Eastern Sierra reflect in the calm waters of Mono Lake at the South Tufa Area.

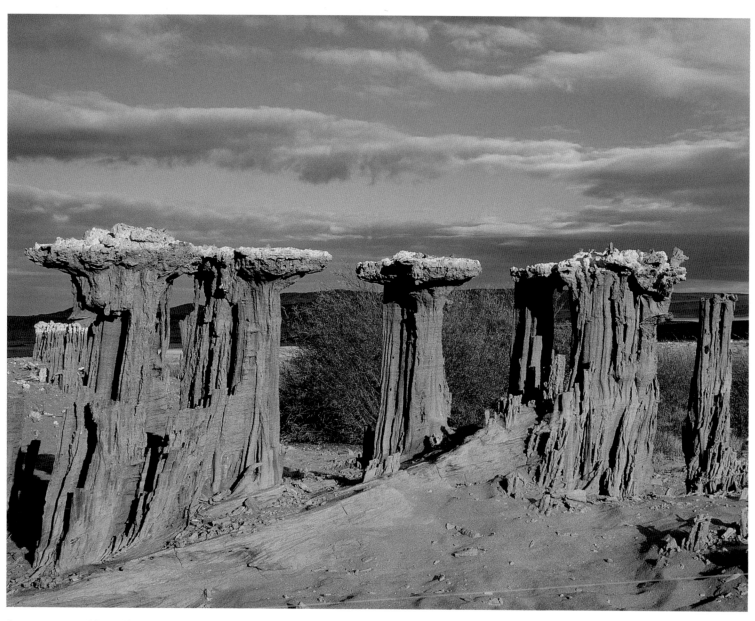

SAND TUFA AT NAVY BEACH, APRIL

Sand tubes and columns, formed when freshwater springs percolated through briny lake bottom sand, were exposed by wind erosion; sand tufa is extremely fragile.

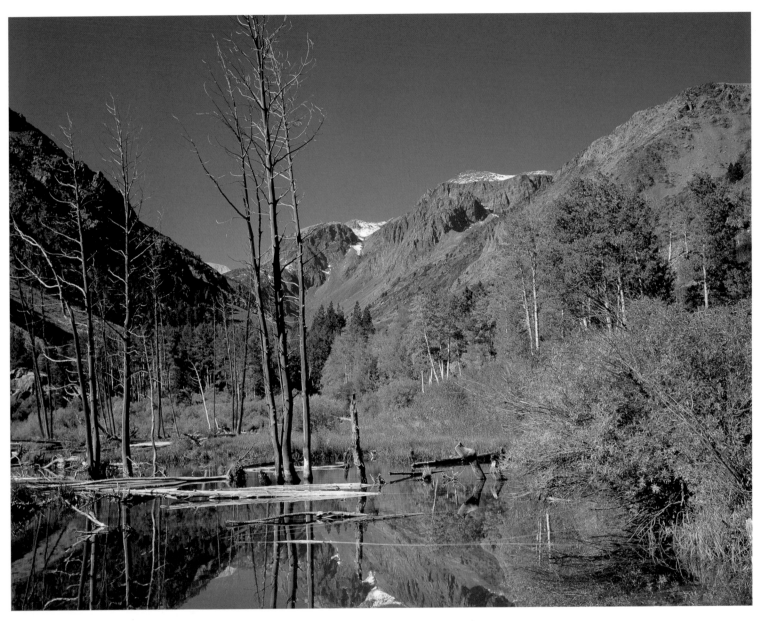

LUNDY CANYON, SEPTEMBER

A still pond, reflecting aspens and snow-dusted Sierra ridges,
formed behind a beaver dam along Mill Creek.

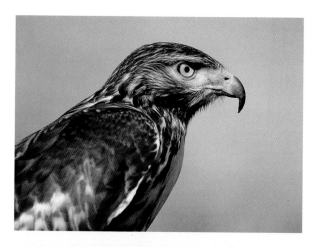
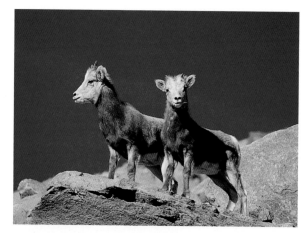
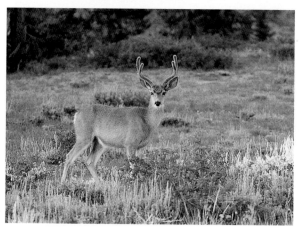
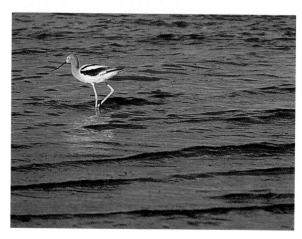

WILDLIFE INHABITANTS

*Clockwise from top left: Red-tail hawk
in Lundy Canyon; juvenile Sierra Bighorn
Sheep [ENDANGERED SPECIES] spotted in Lee
Vining Canyon; an American avocet on
Mono Lake's north shore; a Mule Deer
browses near Parker Bench.*

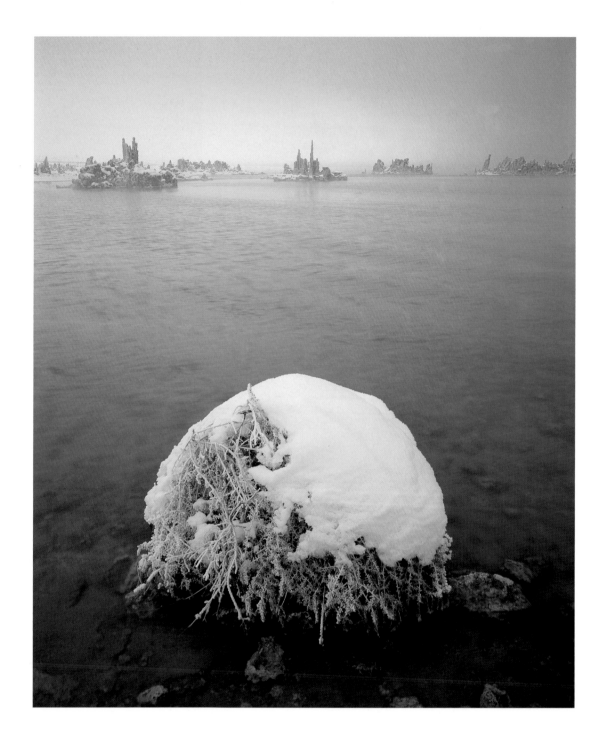

RUSSIAN THISTLE, JANUARY

A cold morning at Mono Lake's South Tufa Area reveals a snow-covered "tumbleweed" resting in the algae-tinted winter waters.

60

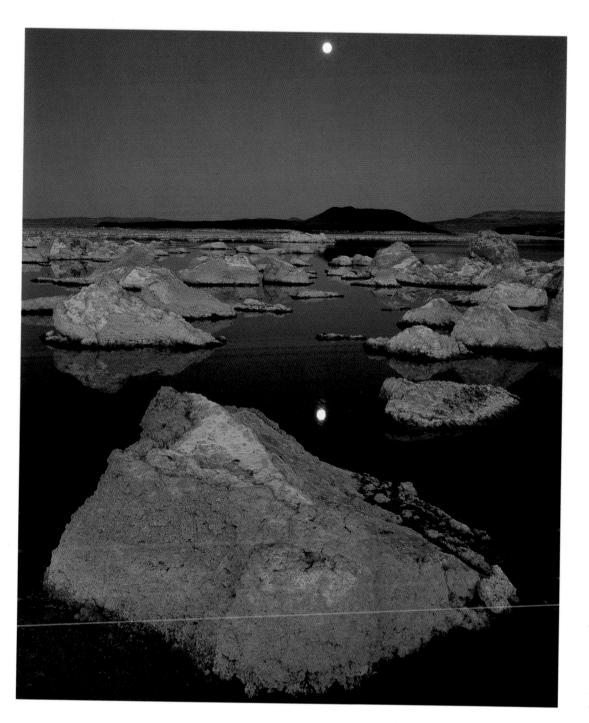

NORTH SHORE, OCTOBER

A full moon rises above Negit Island after sunset, casting reflections of tufa-covered rocks on the still lake. The crusty boulders are actually pumice; blown from a volcanic eruption in the lake about two thousand years ago. Lighter than water, the pumice blocks floated to the lake's surface, lodged on shore, and were gradually covered with a layer of tufa.

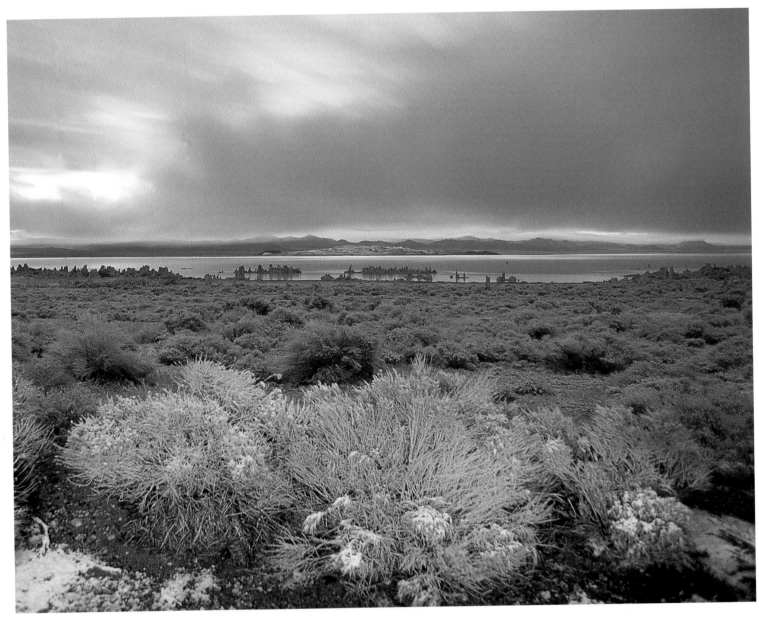

LIGHT–PAINTED BRUSH, NOVEMBER

Plants along Mono Lake's south shore were doused by a late afternoon snowstorm.

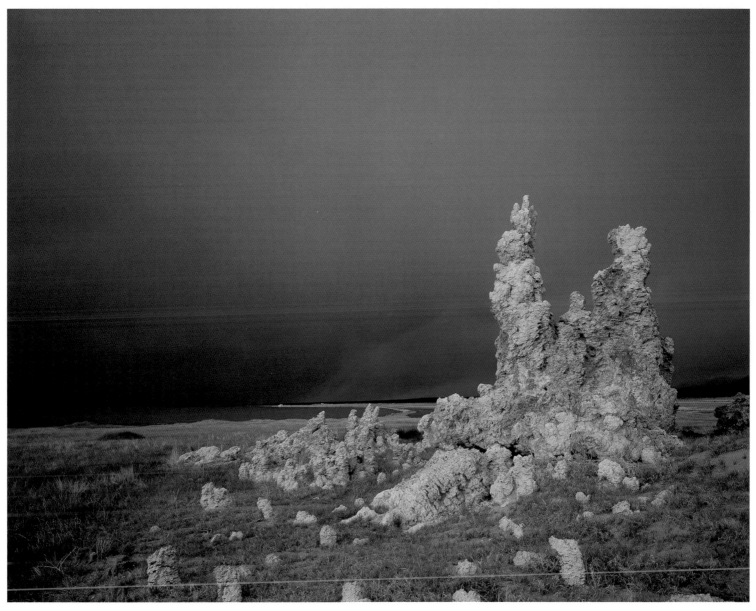

SOUTH SHORE STORM LIGHT, AUGUST

Sunlight breaks through dark skies of a summer afternoon storm,
illuminating tufa towers and a sand bar dotted with feeding gulls.

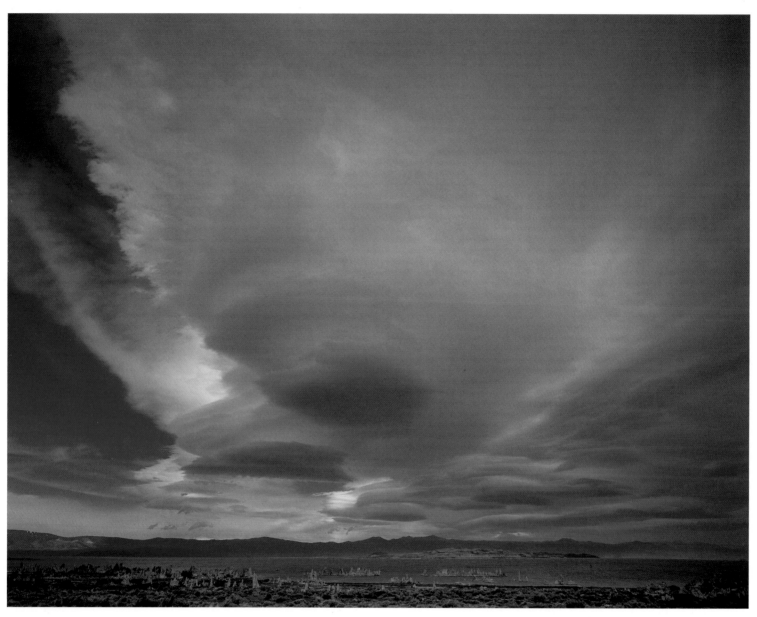

STORM CLOUDS, AUGUST

Summer winds blow up towering cloud formations over Paoha Island.

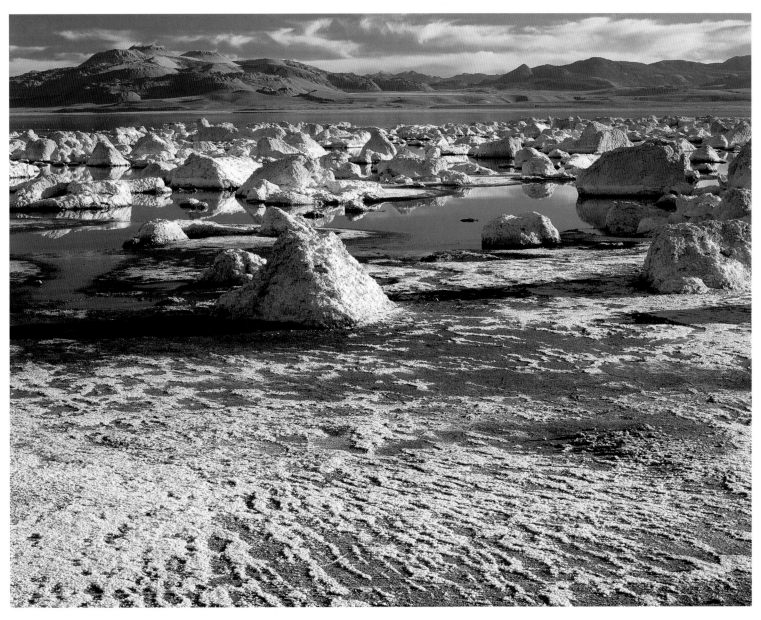

MONO CRATERS FROM THE NORTH SHORE, SEPTEMBER
Calcium carbonate deposits crust the shoreline and cover pumice boulders below Black Point.

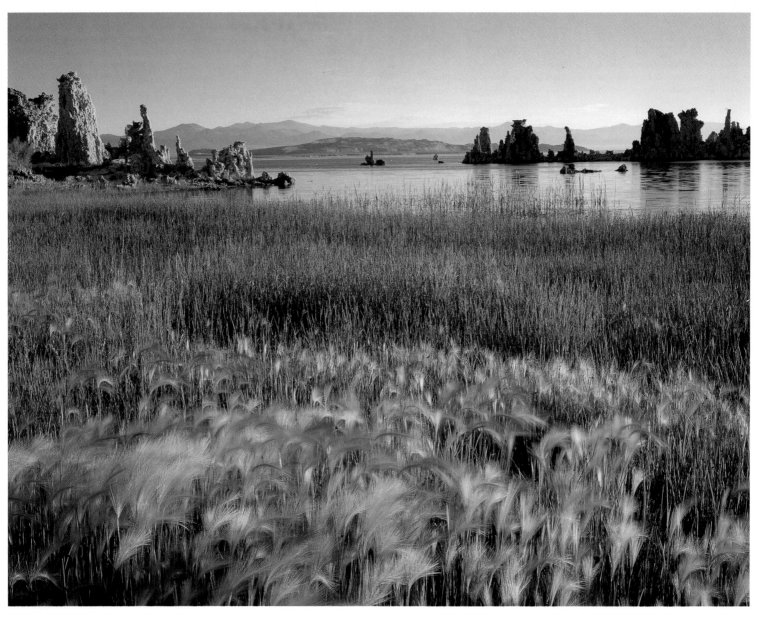

SQUIRREL TAIL BARLEY, JULY
Waving heads and subtle colors of native grasses grace Mono Lake's south shore in summer.

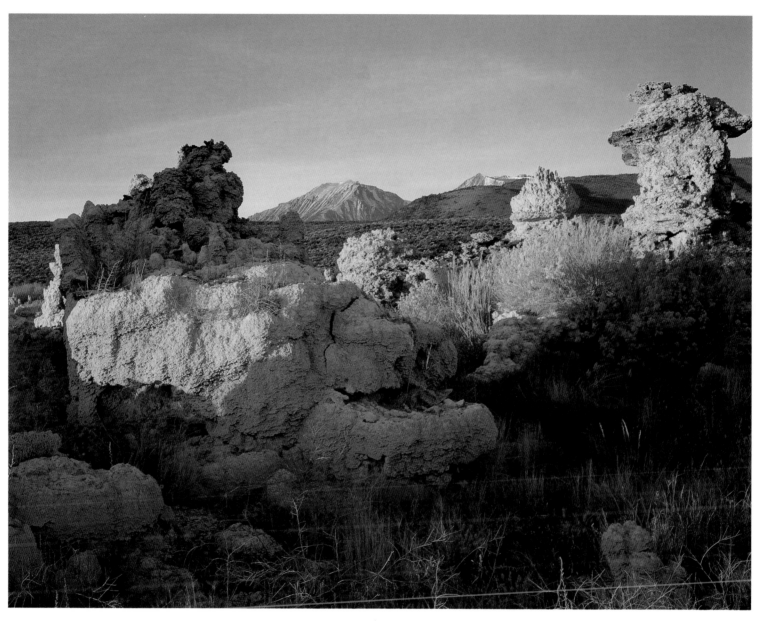

WEST SHORE SUNRISE, MARCH
First light illuminates tufa formations surrounded by grasses and rabbitbrush.

THE LESTER BELL HOUSE AND BARN, JULY

Weathered remains of Bodie, a mining town that boomed in the 1880s, stand in a state of arrested decay at Bodie State Historic Park north of Mono Lake.

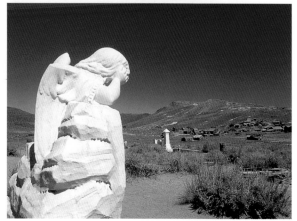

BODIE SCENES

Clockwise from top left: moonrise over the brick Dechambeau Hotel and post office and the wood frame Odd Fellows Hall; a weathered door; view from Bodie's hilltop cemetery; reflections in the Boone Store.

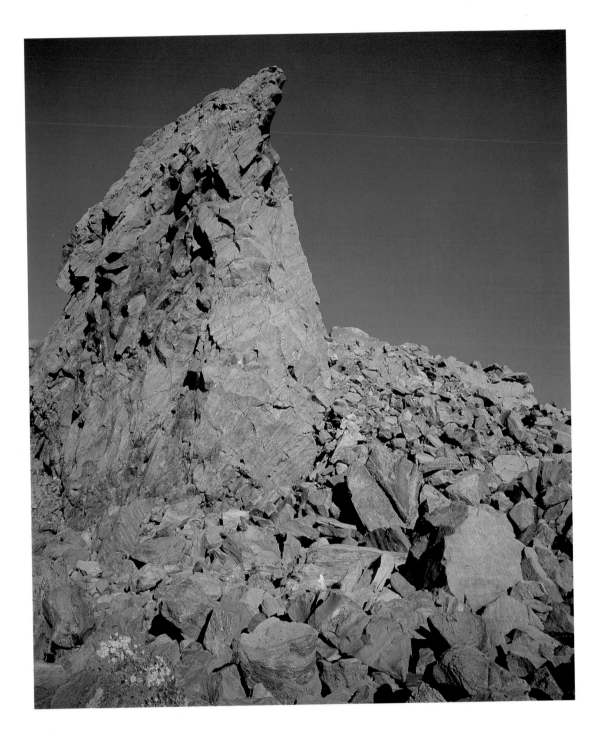

OBSIDIAN MONOLITH, MARCH

Inside Panum Crater, a jumble
of broken rock attests to the power
of volcanic eruptions that formed
the most recent of the Mono Craters.
A classic "plug dome," Panum
Crater is the youngest of the Mono
Craters; it lies near Mono Lake's
South Tufa Area.

SPRING SNOW AT PANUM CRATER, MAY

A brief morning snowstorm lightly dusts the crater rim. Panum Crater's rimside trail treats hikers to expansive views of Mono Basin and its surrounding mountain ranges.

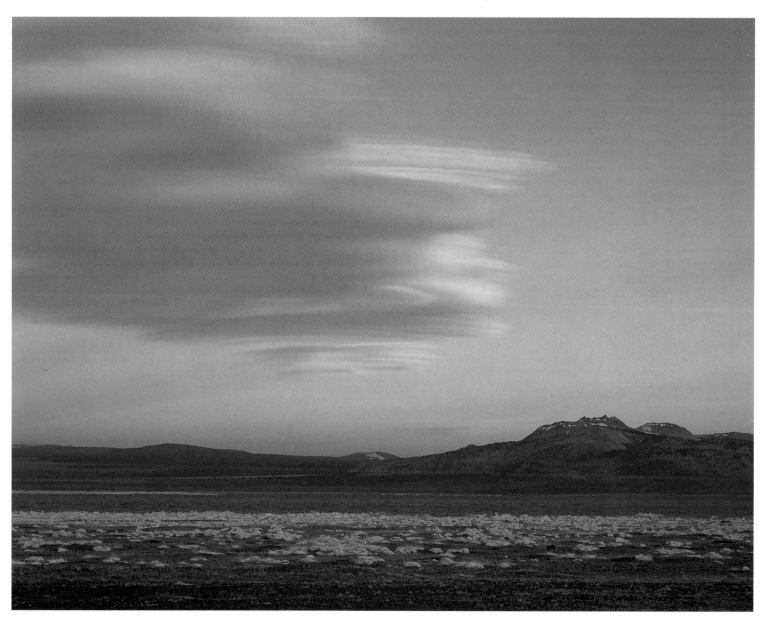

Lenticular clouds after sunset, June

Mono Basin's skies often feature spectacular cloud formations.

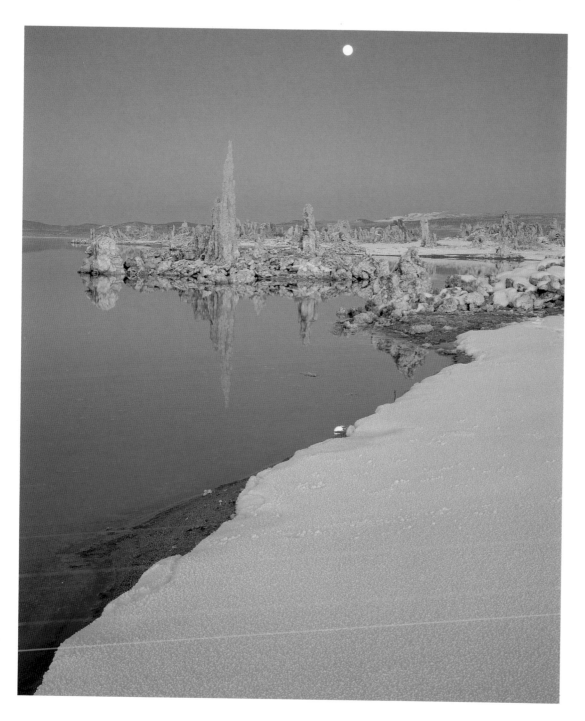

MOONRISE AT
SOUTH TUFA AREA, JANUARY
*Calm lake waters capture the last
moment before the rising full moon's
reflection disappears beneath a
lakeside bank of snow.*

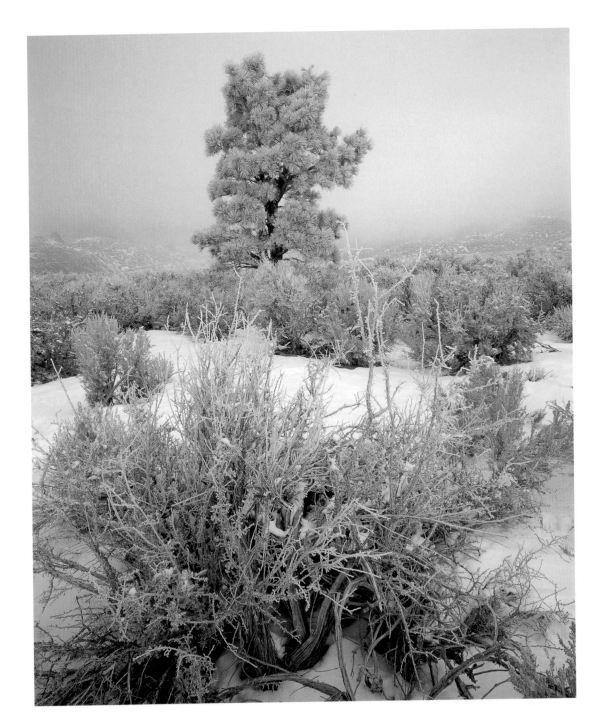

FOG-ENGULFED JEFFREY PINE,
DECEMBER

The Paiute called it "poconip" —
a frozen winter blanket that shrouds
the Mono Basin with an icy sheet.
The low-lying poconip fog layer
holds Mono Lake and its
surrounding shore areas in a below-
freezing grasp until afternoon sun
slowly burns it away.

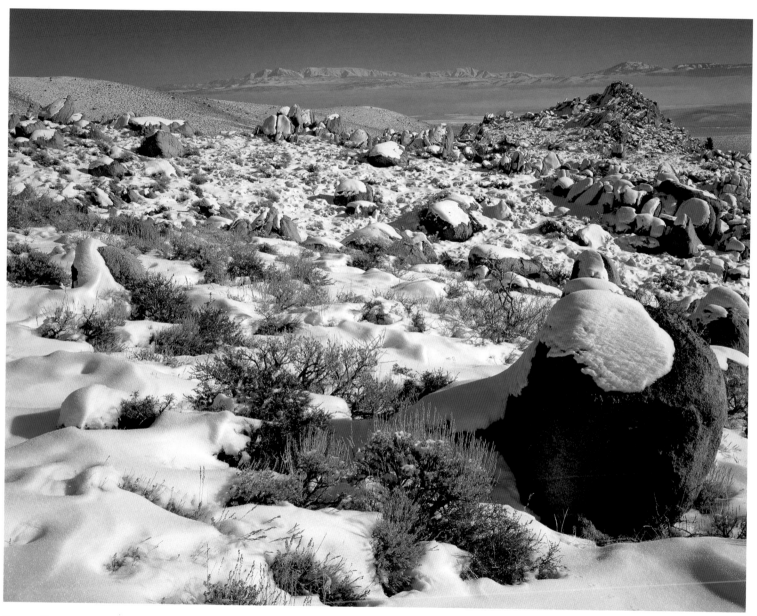

FROM RATTLESNAKE GULCH, DECEMBER

Viewed from near Conway Summit on a winter afternoon, brilliant sunlight bathes the mountain ranges surrounding Mono Lake as poconip fog in the Mono Basin begins to dissipate.

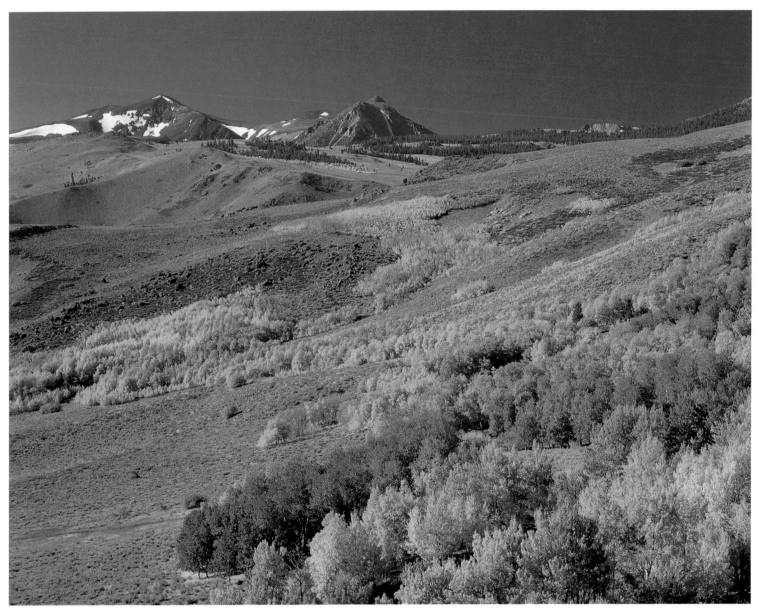

FALL COLOR BELOW CONWAY SUMMIT, OCTOBER
Turning aspens march down the slopes north of Mono Lake in bright yellow and golden formations.

ASPEN LEAVES, LATE OCTOBER
Fallen leaves carpet a stand of aspens just after a brief rain.

EASTERN SIERRA WILDFOWERS

Clockwise, from top: Wild iris; monkey flower blooms in a rocky crevice at Panum Crater; a single aster covered with ice crystals.

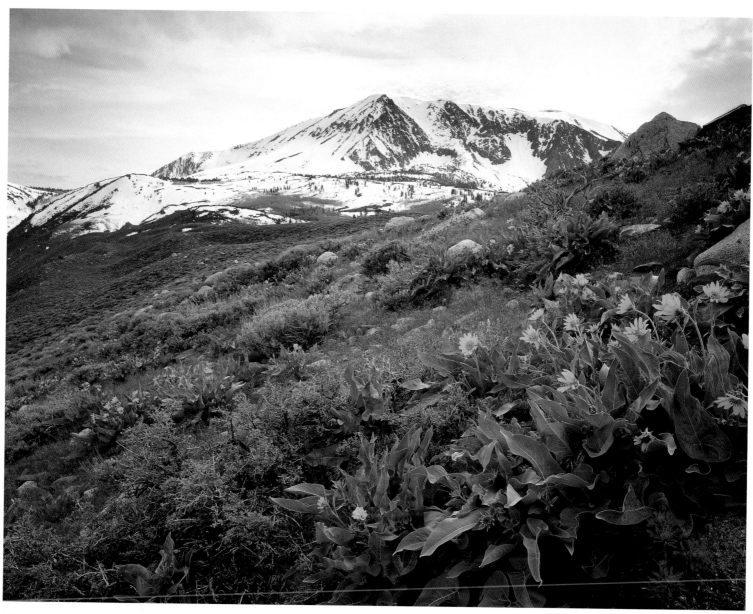

WILDFLOWERS ON THE PARKER BENCH, JUNE

Arrowleaf balsam root and Indian paintbrush bloom on a ridge below the Sierra Nevada.

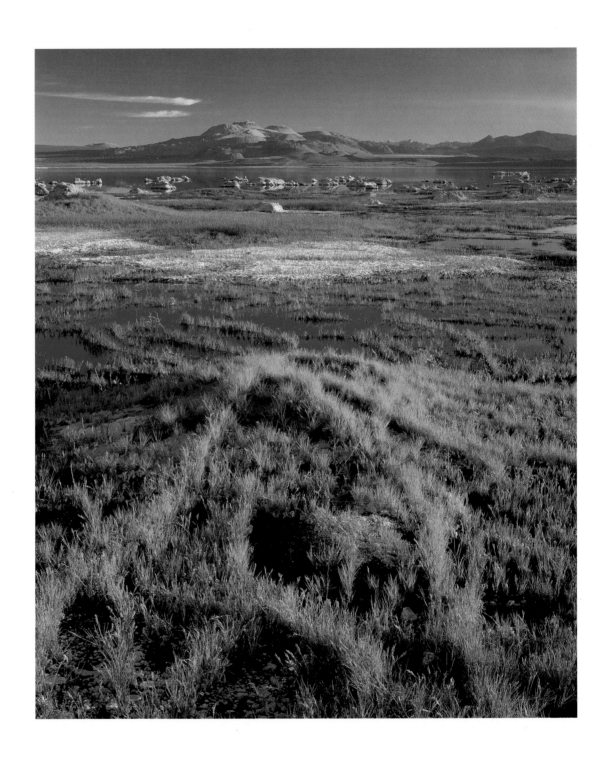

SALT GRASSES, SEPTEMBER

Along Mono Lake's North Shore, salt grasses spring up in green and gold patterns in the wetlands. The volcanic silhouette of the Mono Craters is visible across the lake.

INSIDE PANUM CRATER, JUNE
Lichen grow on huge chunks of obsidian within the crater's west rim.

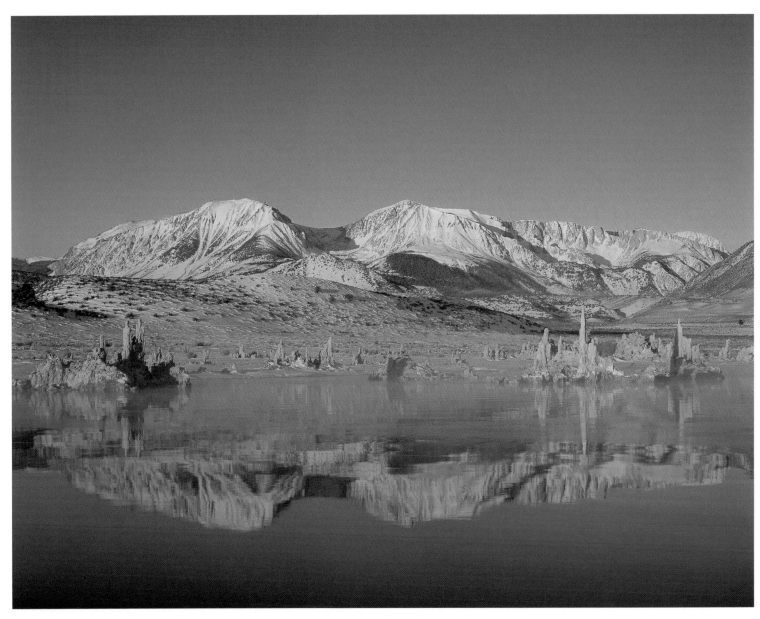

SIERRA SUNRISE, MARCH

Mono Lake's surface mirrors Sierra Nevada peaks Mt. Gibbs (elevation 12,764 feet), left,
and Mt. Dana, (elevation 13,053 feet) and tufa towers at the South Tufa Area.

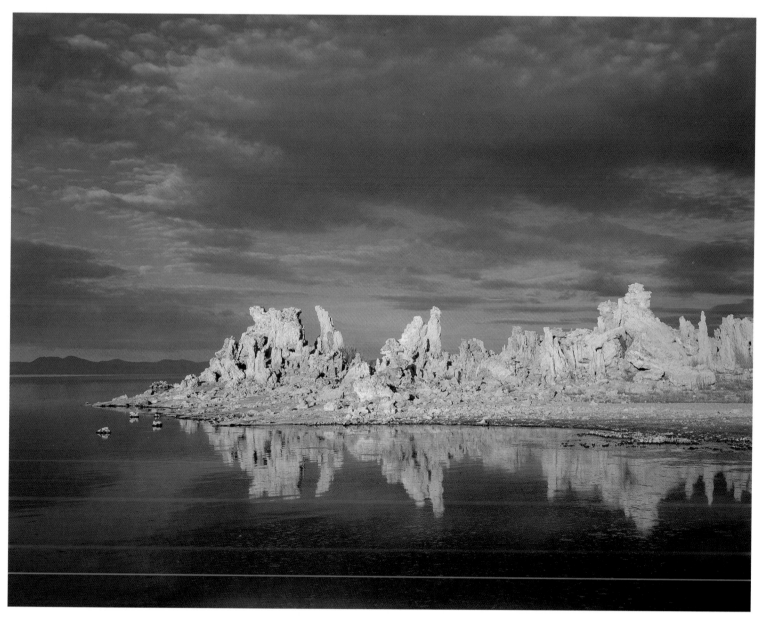

CLEARING STORM, NOVEMBER

In late summer and early fall, Mono Lake provides important habitat for migratory birds. Wilson's phalaropes, red-necked phalaropes, and eared grebes use Mono Lake as a critical stop-over on their long flights to wintering areas, and feed on brine shrimp and flies.

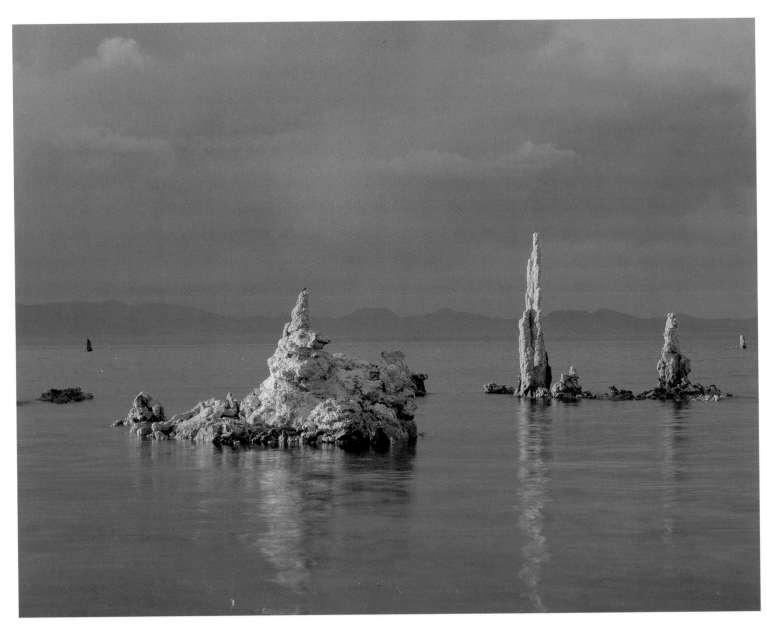

TUFA SPIRES AT SUNSET, OCTOBER

Sculptural tufa forms, their elegant shapes reflected in still waters,
grace Mono Lake's south shore.

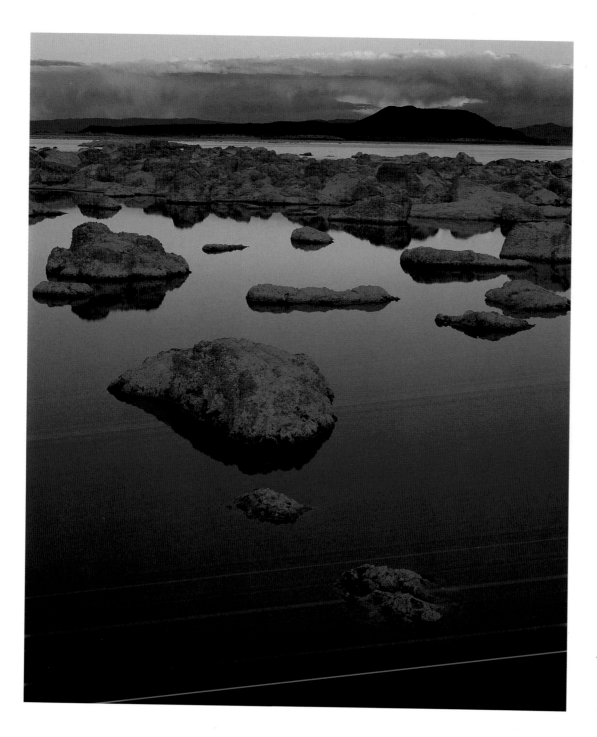

NEGIT ISLAND, DECEMBER

Viewed from Mono Lake's north shore, dark Negit Island looms in the twilight. Nineteenth century geologist Israel Russell named Mono Lake's smaller, darker island, using the local Paiute word Negit *for the blue-winged goose that may once have nested there.*

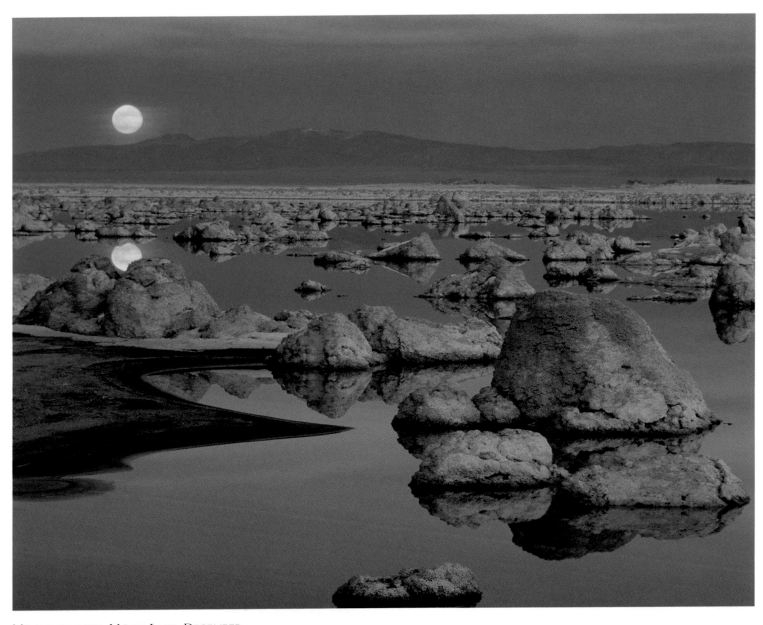

Moonrise over Mono Lake, December

There rests upon the desert plain what appears to be a wide sheet of burnished metal, so even and brilliant is its surface... No prosaic description can portray the grandeur of fifty miles of rugged mountains, rising beyond a placid lake in which each sharply cut peak, each shadowy precipice and each purple gorge is reflected...

—Israel C. Russell

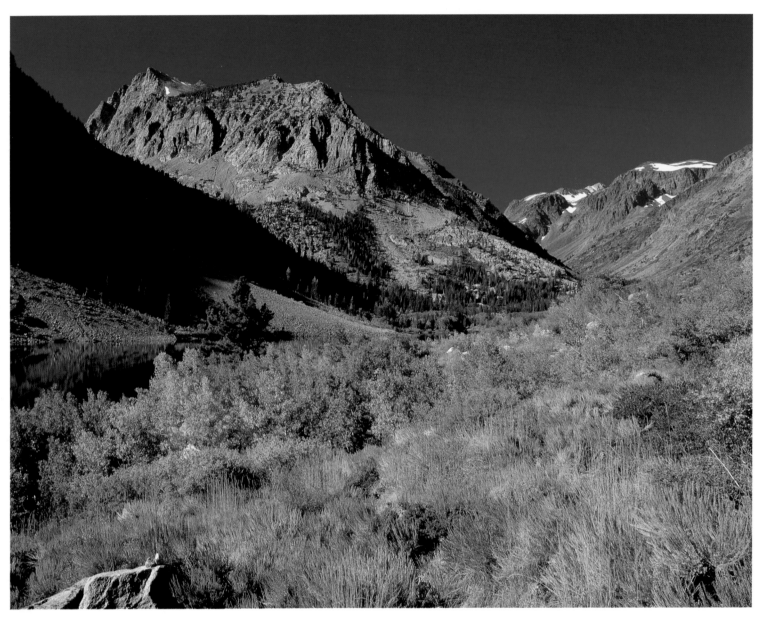

LUNDY LAKE, SEPTEMBER

Fall color descends from a rocky Sierra ridge several miles up Lundy Canyon.

88

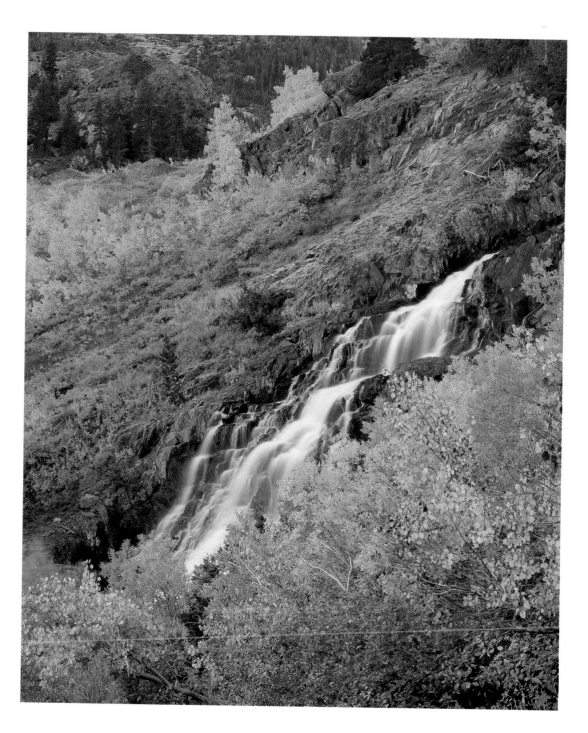

LUNDY FALLS, OCTOBER

Aspen, dogwood, and willow create a collage of changing color around Lundy Falls, high in the Hoover Wilderness Area east of the Sierra Crest.

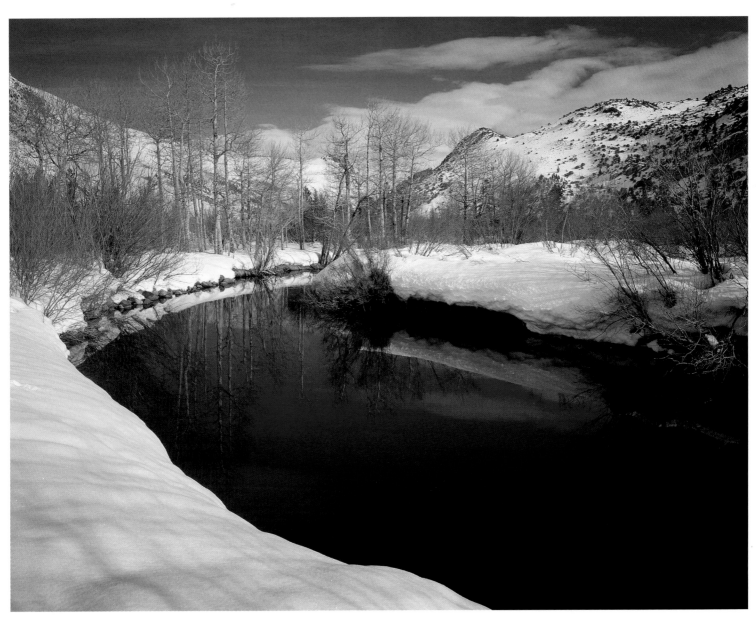

RUSH CREEK ALONG THE JUNE LAKE LOOP, JANUARY

From its high Sierra headwaters, Rush Creek drains northward toward Mono Lake. It slows to a serene reflection in winter, but gains rushing velocity as high country snows melt in spring and summer.

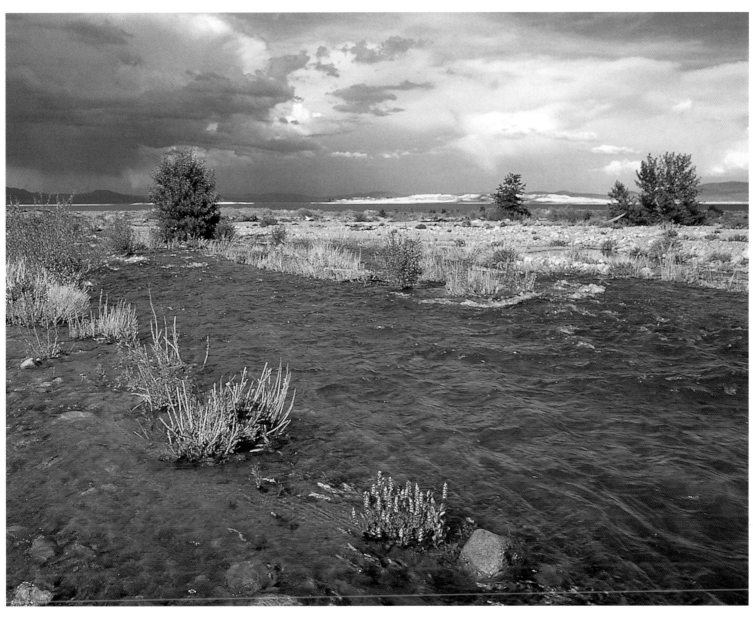

LEE VINING CREEK, JULY

Singing waters of Lee Vining Creek, swollen with late season snowmelt, crest
its banks and engulf a blooming lupine on the way to join Mono Lake.

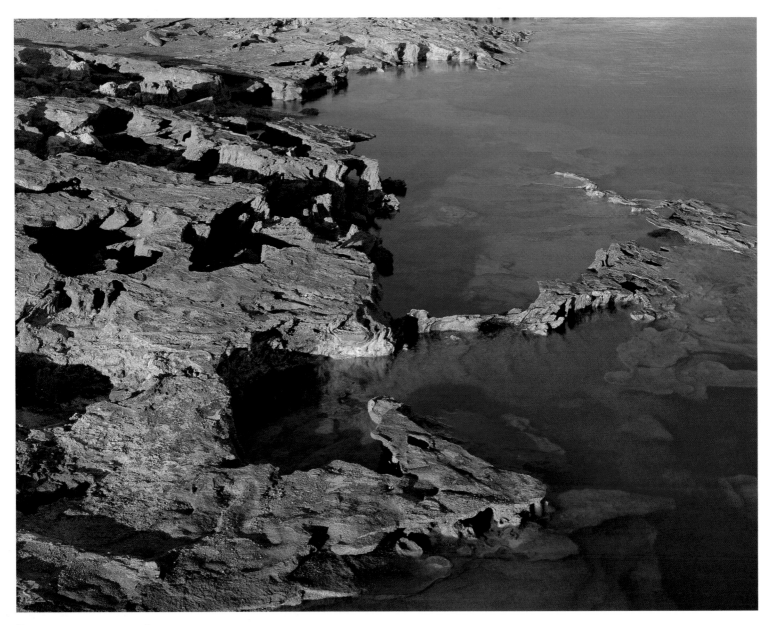

SHORELINE PATTERNS, APRIL

92

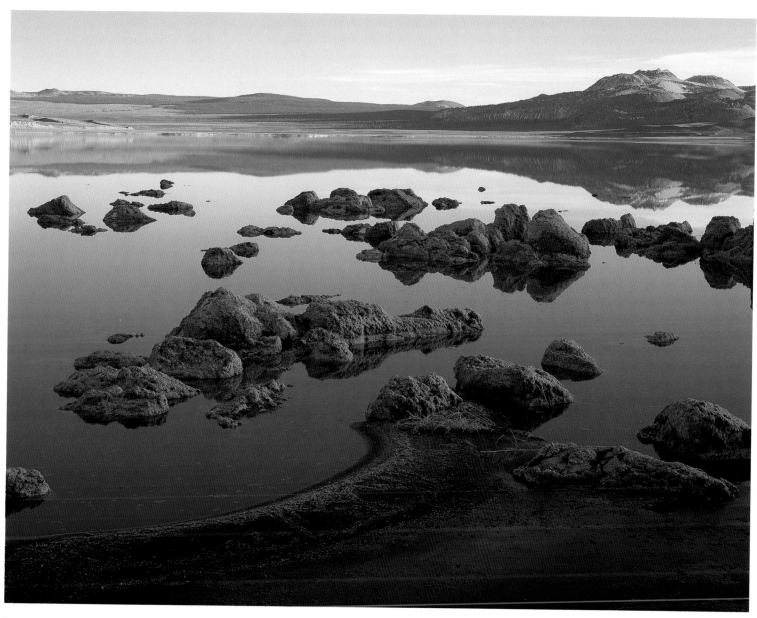

North shore reflections, November

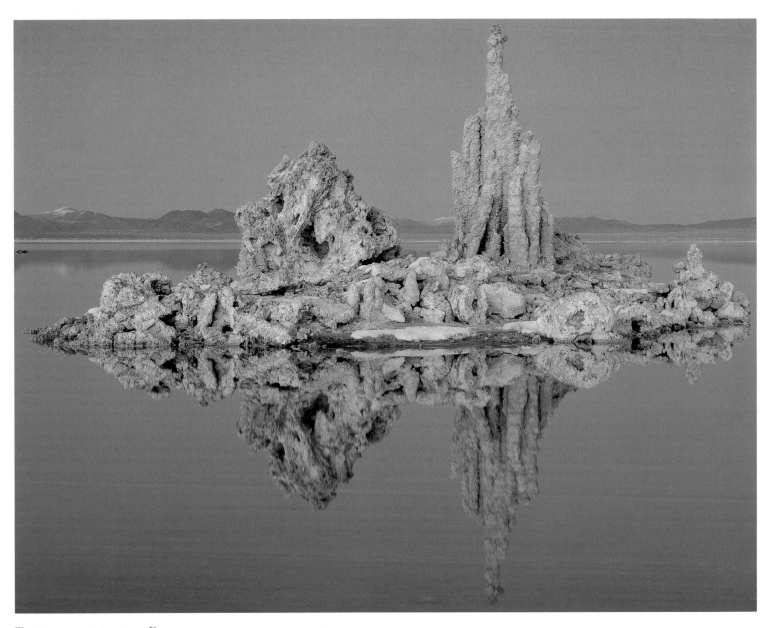

Tufa towers at dusk, December

94

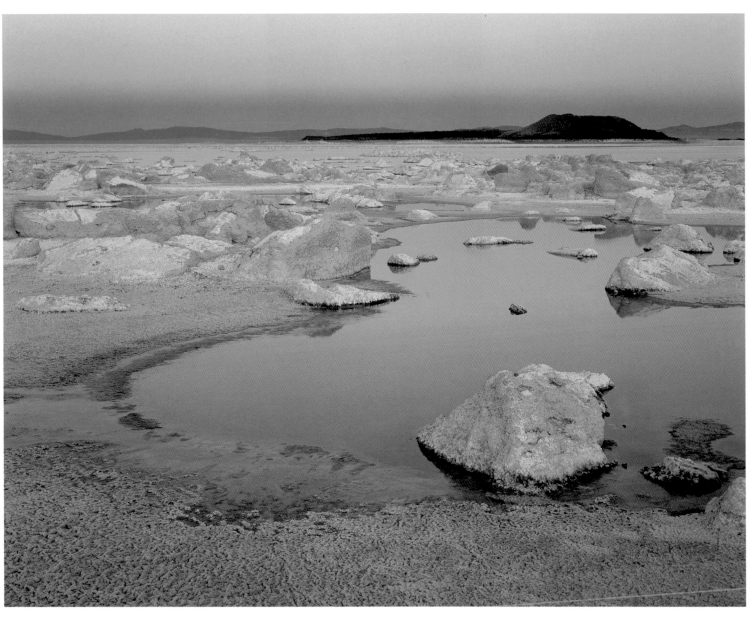

MONO LAKE MIRRORS A TWILIGHT SKY, OCTOBER

Arrowleaf balsam root

PHOTOGRAPHER'S NOTES

I used a variety of camera equipment while photographing for this book. The majority of images were made with a Calumet Wood Field 4x5 camera on Fuji Velvia film. For some of the images, I used Fuji Provia or Fuji 50D film. I also used a Pentax 6x7 or Nikon FE2 camera for a few scenes, using warming, polarizing, or graduated filters as needed. When I used my 4x5 for twilight photos, exposures of between four and twenty seconds were often required. I set up these scenes well before the sun went down—and then waited for that one special moment. During these times of waiting I have come to appreciate the beauty and solitude of Mono Lake.

Selected images from *Mono Lake: Mirror of Imagination* are available as limited edition EverColor Dye Prints from Moments in Time, Ltd., of California. Each ready-to-frame hand-pulled print is museum-quality matted, border embossed, stamped with a registry number, and accompanied by a certificate of authenticity signed by the photographer. For selection and order information, call (800) 533-5050.